SOUTHWARK & BLACKFRIARS
IN 50 BUILDINGS

LUCY McMURDO

AMBERLEY

For Mac, my wonderful walking partner, photographer and best friend.

First published 2023

Amberley Publishing, The Hill, Stroud
Gloucestershire GL5 4EP

www.amberley-books.com

British Library Cataloguing in Publication Data.
A catalogue record for this book is available from the British Library.

ISBN 978 1 3981 0149 4 (print)
ISBN 978 1 3981 0150 0 (ebook)

Typesetting by SJmagic DESIGN SERVICES, India.
Printed in Great Britain.

Contents

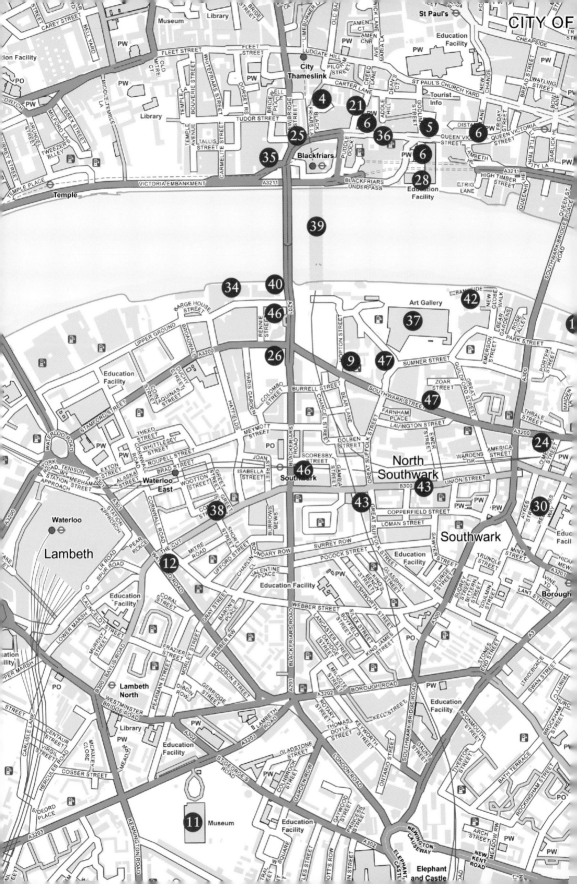

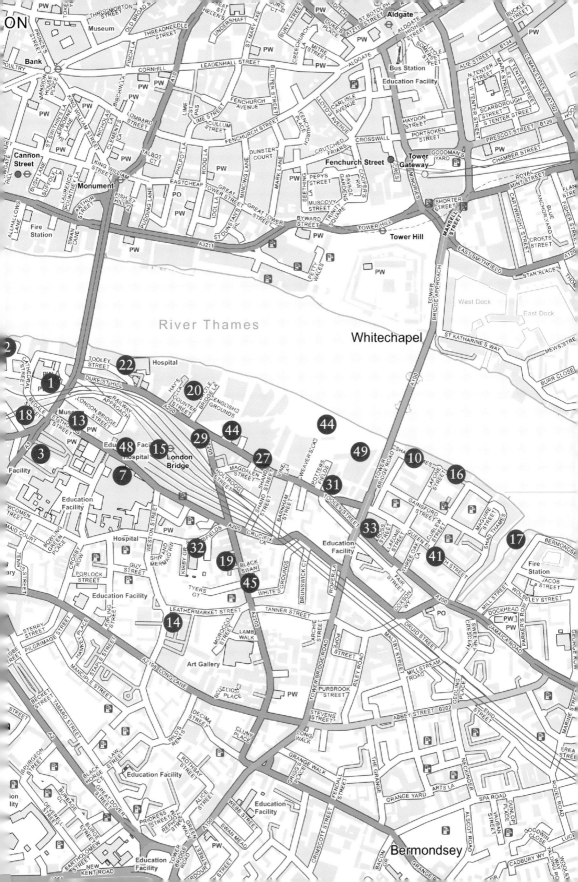

Key

Introduction

Southwark and Blackfriars are two of London's most interesting neighbourhoods and although separated by its main artery, the River Thames, have many characteristics in common. They have histories dating back 2,000 years to the time of the Roman occupation, and both were hubs of religion during the medieval period. They also have great literary connections and are closely associated with theatre and entertainment, and are places where William Shakespeare (1564–1616) wrote plays and appeared on the stage. Prisons were one of Southwark's major features from the Middle Ages and included debtors' as well as criminal institutions. A vivid description of prison life appears in Charles Dickens' writings resulting from his own experience of visiting his father in Southwark's Marshalsea prison. In Blackfriars, the royal Bridewell Palace was subsequently converted into a prison and because of the harshness of its regime its very name 'Bridewell' became synonymous with large institutions, prisons and houses of correction, not only in Britain but in the USA too.

In Roman times Southwark was to all intents and purposes a suburb of 'Londinium', the name by which Roman London was known. Located beside the Roman river crossing, it was the first settlement to be reached on the south side of the river. The Thames at this time was much wider and shallower, interspersed with gravel islands upon which the settlement of Southwark developed. Surrounded by marshland, it was not the most hospitable of places but it became the main route into London from the Continent and Kent, something that continues to this day. Recent excavations by Museum of London Archaeology (MOLA) have discovered buildings and many artefacts from around AD 72 showing that high-ranking Roman officials and soldiers once lived here.

One of the district's most important buildings was the Benedictine Bermondsey Abbey. Founded in the late eleventh century, it was to become one of London's wealthiest and most spiritual of religious foundations, almost rivalling Westminster Abbey in importance. Yet it was forced to close when the monasteries were dissolved in the 1530s and all its extensive land and buildings were sold off. Although long since gone, the abbey is still remembered today in Bermondsey Square, built on the religious foundation's original site. Closer to the river is Southwark Cathedral, once a monastery and medieval priory under the auspices of the Bishop of Winchester. It is an awe-inspiring building filled with fascinating history and contains many memorials, as well as the Harvard Chapel, named after former local resident John Harvard. He left home for America in the 1630s and

on his death there bequeathed half of his estate and his scholarly library to the local college. As a result of his bequest the college adopted his name and has been known as Harvard University ever since.

Probably the most significant structure to have made an impact on Southwark's growth and prosperity has been London Bridge. The Romans built the first wooden crossing, and when this corroded it was succeeded by further timber bridges until a stone bridge was finally erected in 1209. This bridge with its nineteen piers and arches had a wooden drawbridge, a stone gatehouse, many houses, shops, watermills and even a chapel. It served London for 600 years until it had outlived its use and was rebuilt in 1831 by the architect John Rennie. In fact, London Bridge was the sole bridge crossing the Thames until the mid-eighteenth century. In the early 1970s Rennie's bridge too needed to be replaced, so was sold and dismantled, then transported to America where it now crosses Lake Havasu in Arizona. The new bridge, still in situ, has a wider span yet is a somewhat plainer structure. For around 2,000 years London Bridge has acted as a conduit between Southwark and the City of London carrying not only pilgrims, merchants, commuters and travellers but also goods, especially those manufactured south of the river. As the City forbade noxious and dirty industries from trading within its confines all such industry took place in Southwark. This led to Southwark's renown as an area of foul odours – largely emanating from its tanning and leather industries. The entire area was filled with yards, tanning pits, factories, brewhouses, wharves, and warehouses that ran along the banks of the Thames and inland into Bermondsey and Borough (the area that stretched southwards from London Bridge). Southwark's population grew markedly in the eighteenth and nineteenth centuries and employment was plentiful not just in the leather and tanning industries but in the wool, glass-blowing, maritime, brewing, hop, and hat-making industries too. From the late eighteenth century and for the best part of 200 years Christy's, the internationally renowned hat manufacturers, occupied premises on Bermondsey Street, and the eighteenth-century Anchor brewery only closed its Horselydown brewery doors in the 1970s. Fortunately, many of Southwark's glorious buildings and structures from the 1800s still exist: the Leather Market and Leather Hide & Wool Exchange on Weston Street, the Hop Exchange in Southwark Street and the iron walkways in Shad Thames are all wonderful illustrations of the district's Victorian industrial heritage.

The very first and highly successful London railway was launched at London Bridge in 1836 and today Southwark is criss-crossed with Victorian brick-built railway viaducts and arches. In recent times many of the latter have been repurposed (demonstrated in the newly opened Borough Yards) and now function as shops, cafés, bars, restaurants and even theatres. The railway, from the time of opening, had an enormous impact on the area and the present London Bridge station has recently undergone a massive overhaul, which has made it a destination

in its own right. Sitting beside London's tallest building The Shard, designed by internationally celebrated architect Renzo Piano, it has its own shopping arcade and an abundance of eateries.

Southwark has always been a centre of entertainment and it was particularly known for its brothels, pubs, playhouses, cockfighting, and bear gardens in the sixteenth and seventeenth centuries. These were pursuits frowned upon by the City authorities, which explains their presence on this side of the Thames. Bankside was home to a number of outdoor theatres and plays of the day were staged here. William Shakespeare, apart from being a shareholder in the Globe, was also one of its major playwrights. His plays attracted large audiences and made the theatre extremely popular, enhancing the Globe's reputation. However, in 1642, all of London's theatres were forced to close by the Puritan led parliament that did not approve of them, considering them to be vulgar. It took more than 300 years until a replica Globe Theatre was once again constructed on Bankside and this came only after a long and protracted campaign by the American film director and actor Sam Wanamaker. Opened in 1997, it is once again today a major landmark on Southwark's riverside. Interestingly, theatre is still a very popular form of entertainment here and the area has its good share of fringe theatres, as well as its own children's theatre, The Unicorn, the recently opened Bridge Theatre beside Tower Bridge, as well as the much-loved Old Vic and Young Vic Theatres (based just outside the borough's borders in Lambeth).

Throughout the 1800s Tooley Street and the riverside between London Bridge and Tower Bridge was nicknamed 'London's Larder'. It teemed with activity and ships from around the globe offloaded their produce including tea from China, and meat and frozen dairy products from New Zealand and Australia. Nowadays the stretch between the two bridges is best known for its riverside promenade, restaurants and the magnificently renovated Hay's Galleria.

Blackfriars, north across the river, has an equally long and fascinating history. Located on the western edge of the City of London inside the city walls, it has always been a key settlement. After the Romans left London in the fifth century its residents moved west but reinhabited the area in the late ninth century and by the time of the Norman Invasion in 1066 Blackfriars and the city were thriving once again. The Normans built Mounfiquet and Baynard castles to act as defence strongholds beside the River Thames and its tributary, the River Fleet. Although they were formidable structures both had been demolished by 1213 and the land on which they stood sold to Dominican friars. Baynard's Castle was in fact rebuilt and used by monarchy until the reign of Henry VIII but later burnt down in the Great Fire of London. The new Dominican priory extended over an area of 8 acres and included a church, cloisters, a great hall, guesthouse and refectory. It was held in high esteem by royalty, so much so that it hosted state visits and was even the setting for Henry VIII's divorce hearing with his first wife, Katherine of Aragon. The name Blackfriars owes its derivation from

the black attire worn by the Dominican monks and has been in use from at least the early 1300s.

Despite the excellent relationship between monarchy and the monks the priory closed in 1538 as a result of the Dissolution of the Monasteries, after which its land was sold off. In the late 1500s the Burbage brothers acquired some of the land for their Blackfriars Theatre and it was here in 1509 that Shakespeare not only performed but also became a part shareholder of the establishment. Unlike the uncovered playhouses south of the river, Blackfriars was roofed allowing it to be used all year round. Documentary evidence shows that Shakespeare purchased a property nearby the theatre in Ireland Yard, but it is not known whether he ever resided there. Nothing of the theatre survives today but the hall built by the Worshipful Apothecaries on the guesthouse of the former priory in 1670 remains in use in Black Friars Lane. The Blackfriar pub, located on Queen Victoria Street, sports the figure of a jolly friar on its façade and is the only reminder nowadays of the monks who lent their name to the area.

Close to the priory was Bridewell Palace (now partly covered by Unilever House). It was a large residence used by sovereigns until the time of Henry VIII but in later years became a notorious prison much feared by the population. It finally closed in the mid-1800s and all traces of it have since been lost.

Blackfriars, like the rest of London, suffered great damage during the Great Fire of London in 1666 and again during the Second World War. On both occasions it lost many buildings that had an impact on its urban landscape. Although three of its medieval churches succumbed to fire in 1666, they were quickly rebuilt by the renowned architect of the day, Christopher Wren. Two of the three suffered great devastation again during the 1939–45 war but with post-war restoration all three still stand in Queen Victoria Street and are wonderful examples of Wren's genius. They, like many of the buildings in this book, appear on English Heritage's Register of Listed Buildings, a designation that recognises historic and/or architectural significance. This 'listed status' (ranging from the top Grade I, through II* to II) necessitates strict planning rules and this helps to prevent essential features of the buildings from being lost, preserving them for future generations.

Nowadays Southwark and Blackfriars work hard to maintain and display their heritage yet always take heed of the need to move with the times. Old Victorian buildings sit alongside state-of-the-art glass edifices, and throughout the district warehouses, a magistrates' court and even power stations have been put to entirely different uses. New areas such as the Shard Quarter and London Bridge City have been developed and Blackfriars railway station now has entrances on both sides of the river.

Although not all of their original buildings have survived just a stroll around Southwark's and Blackfriars' streets gives visitors a most valuable insight into the wealth of social, religious and industrial history here, as well as displaying marvellous range of architecture from the Gothic to the contemporary designs of twenty-first century London.

How to use this book

In accordance with the 50 Buildings series, the buildings appear in chronological order according to the time of their original construction.

The accompanying map identifies each building by a number that corresponds to the numbers used in the text.

Website information for buildings that are open to the public is provided at the end of each chapter.

Please note. Due to the size of the Borough of Southwark it has been impossible to include buildings from all its parts. So, the buildings that appear in the book are those that sit right beside or near the River Thames on Bankside or a little inland in the areas of Bermondsey and the Borough.

The 50 Buildings

1. Southwark Cathedral, London Bridge, SE1

Southwark Cathedral, officially named the Cathedral and Collegiate Church of St Saviour and St Mary Overie, is less well-known than either Westminster Abbey or St Paul's Cathedral yet is one of the capital's most treasured buildings. It is not only a magnificent Gothic structure but also full of a wealth of interesting monuments and memorials, including the impressive Harvard Chapel (in memory of the Southwark parishioner John Harvard after whom Harvard University was named) with its tabernacle designed by Augustus Pugin.

Sited at the southern end of London Bridge, a major entry and exit point to the City of London, the cathedral is easily identified by its soaring roof, prominent four pinnacle tower and fine flint and ashlar exterior. The church was built on the site of a Roman villa, which later became a convent, then a Saxon monastery, and finally a medieval Augustinian Priory under the jurisdiction of the Bishop of Winchester. Following the country's religious turmoil of the 1530s the priory closed and its buildings, apart from the church, became the property of the king. The church then served as a parish church until 1905 when, due to an increase in the area's population, it was awarded cathedral status, responsible for its own large diocese.

Some of the cathedral's early features such as the east front, choir and retrochoir still exist but many changes have been made to it over the years. Most recently, in 2000 a most sympathetic extension was added that provided a refectory, shop, library and education centre.

Southwark Cathedral is particularly renowned for its association with great literary figures such as Geoffrey Chaucer, John Gower, William Shakespeare and Charles Dickens. In the south aisle there is a delightful monument of a reclining Shakespeare beneath a beautiful stained-glass memorial window that contains characters from his many plays. Right beside the window is a poignant plaque commemorating American film actor and director Sam Wanamaker (1919–93), who spearheaded the rebuilding of the modern Globe Theatre on Bankside that opened in the 1990s.

The cathedral today is especially known for its musical excellence and runs a programme of weekly organ and music recitals.

www.cathedral.southwark.anglican.org

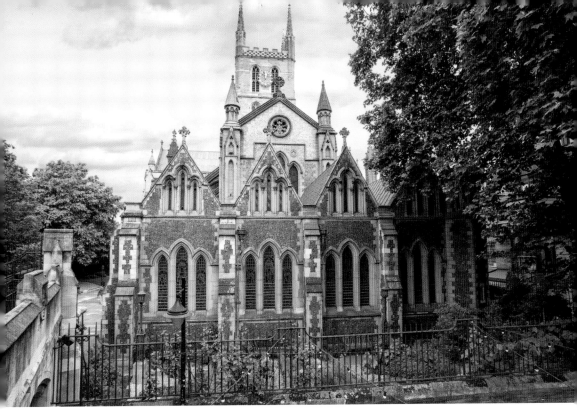

Above: Southwark Cathedral.
(Alex McMurdo)

Right: Statue of Minerva in
front of Southwark Cathedral.
(Alex McMurdo)

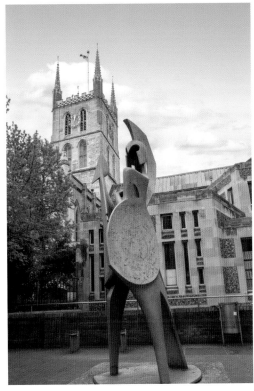

2. Winchester Palace and the Clink Prison, No. 1 Clink Street, SE1

Just a stone's throw away from Southwark Cathedral is what remains of the magnificent Winchester Palace, once home to the exceedingly powerful and influential Bishops of Winchester. In medieval London this enormous residence fronting the River Thames was a sight to be seen, with its cavernous Great Hall and highly decorative rose window it extended across 70 acres (28 hectacres) and possessed a granary and mill, as well as animals and fish ponds. Built in the twelfth century, it remained the prime London residence of the bishops from the 1140s to 1626 and was one of several sizeable properties alongside the river that were owned by other members of the clergy such as the Prior of Lewes and the Abbot of Battle. Nowadays it is hard to picture the immensity of the site as there

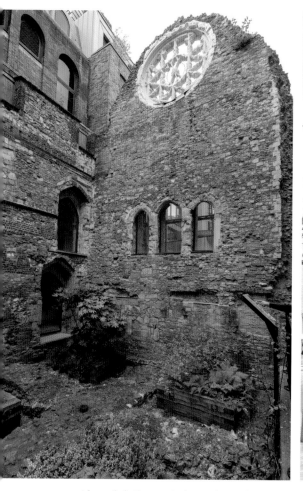

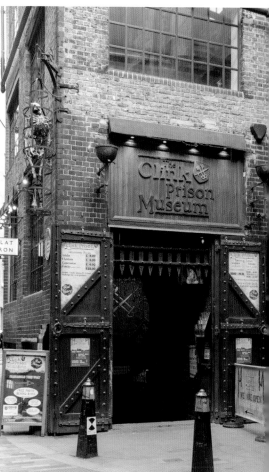

Above left: Rose window of Winchester Palace. (Alex McMurdo)

Above right: The Clink Prison Museum. (Alex McMurdo)

is little left apart from the palace's splendid rose window on the southern wall of the Great Hall. Yet, in its day Winchester Palace was an impressive estate and it was the bishop rather than the king who bore responsibility for law and order in this district known as the Liberty of the Clink. It was therefore the bishop who meted out fines and prison sentences to those breaking the law such as prostitutes, actors, heretics, drunks, debtors and religious dissenters.

The prison lay within the palace grounds and was notorious for its terrible unsanitary conditions, its damp, and horrific overcrowding. Operating from the twelfth to the late eighteenth century those who were unfortunate to be incarcerated within its walls comprised both men and women. Many of the women prisoners were prostitutes who worked in the Thameside brothels, (nicknamed 'Winchester geese'), who were thrown into prison as they were unlicensed for their work. Ironically, it was the Church under the Bishops of Winchester that licensed Southwark's prostitutes for almost five centuries!

The prison became known as the 'Clink' – a word now commonly used to describe a jail or prison. Today, a visit to the Clink Prison Museum provides a superb insight into the life of the prisoners, conjures up the prison's smells and sounds and displays the instruments of torture once used here.

3. The George Inn and Borough High Street, SE1

The George Inn, owned by the National Trust, is one of Southwark's most historic pubs. The present timber and brick inn dates to 1677 (a replacement for an earlier pub that burnt down in the mid-1670s) and was originally constructed around a courtyard with galleries on three sides. Over the years the inn lost two of its galleries but, fortunately, one gallery and its cobble stone courtyard survived, making it the sole galleried coaching inn in London today. In the Elizabethan era the courtyard was used as a type of pop-up theatre, with customers watching performances in the yard or in the galleries. As they entered through the gates they put money into a box, which would then be lodged in the office inside the building, giving rise to the term box office. It is easy to visualise the players performing here and to imagine how the George Inn would have looked (from the late seventeenth to early nineteenth century) as a coaching inn when the yard was filled with coaches and wagons arriving and departing, transporting passengers as well as goods and raw materials.

Nowadays the George's customers are mainly tourists enjoying the pub's architecture and charm, as well as its food and drink. With many original features (wood-panelling, moulded dados, and cornices) it is unsurprising that the pub carries Grade I listed status. The George's interior with its labyrinth of rooms, uneven wooden floors, and dogleg staircase gives one a sense of time gone by. Charles Dickens referred to the George in *Little Dorrit* (1857) and it is easy to imagine how merchants, travellers and pilgrims would all

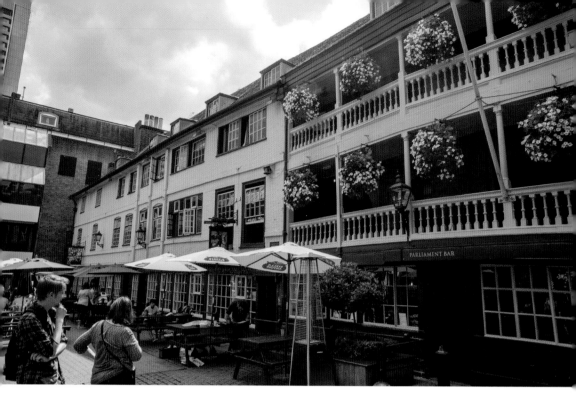

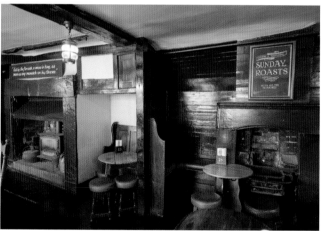

Above: The George Inn. (Alex McMurdo)

Left: The George Inn. (Alex McMurdo)

have enjoyed food and lodging here in the past. Situated on the main road into the City of London from the south, the George, along with neighbouring hostelries – the Black Swan, Queen's Head and White Heart – was always busy. Despite the disappearance of most of these inns Borough High Street still bears evidence of their existence in turnings off the street such as King's Head Yard and Talbot Yard, the latter being where Chaucer's famous Tabard Inn (where *The Canterbury Tales* was set) once stood.

www.greeneking-pubs.co.uk

4. The Apothecaries' Hall, No. 10 Black Friars Lane, EC4

The site that is now occupied by the Apothecaries' Hall was formerly the guesthouse of the Dominican Priory of Black Friars. Although the priory was dissolved during the religious turmoil of the 1530s, it was the order that lent its name to the area we now refer to as Blackfriars. The Worshipful Society of Apothecaries built their hall here in 1670. Although the building has undergone some alteration during its 350-year existence, it still boasts much of its seventeenth-century fabric; this can be seen externally on the north and east courtyard ranges and within the building itself in its first floor Hall, Court Room and Parlour. The Great Hall has a particularly attractive Minstrel's Gallery at one end and a carved screen at the other, while beautiful original panelling, stained-glass windows and carved woodwork are displayed in the Court Room and Parlour. Evidence of the priory's medieval remains are found in the cellar under the east wing, as well as in its outer wall.

Initially the society was part of the Grocers' Company, but King James I supported its independence and awarded the Society its own royal charter in 1617.

Below left: The Apothecaries' Hall entrance. (Alex McMurdo)

Below right: The Apothecaries' Hall stairwell. (Alex McMurdo)

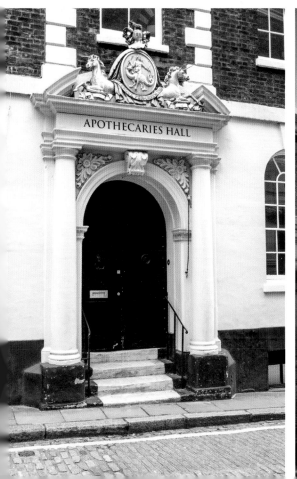
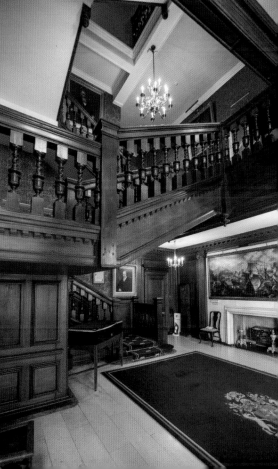

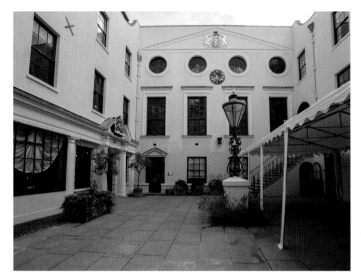

The Apothecaries'
Hall courtyard.
(Alex McMurdo)

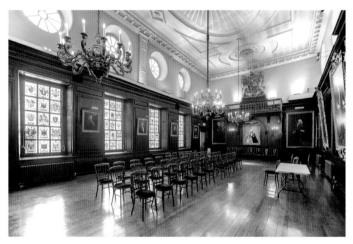

The Apothecaries'
Great Hall.
(Alex McMurdo)

It is now one of the largest of the City's livery companies and designated number 58 in their order of precedence. Since 1815 it has licensed doctors to practice medicine and acted as a medical examining body. It offers and examines students for seven exclusive diplomas not on offer elsewhere that include Medical Jurisprudence (for forensic pathologists), the Medical Care of Catastrophes, Forensic Medical Sciences and HIV medicine. From the late 1600s until the early twentieth century, the Apothecaries' Hall was a key centre for the manufacture and sale of drugs. Furthermore, in 1673 the Apothecaries' Society founded the Chelsea Physic Garden to grow plants for medicinal use and managed the garden until the late 1890s.

Nowadays, like many of London's livery companies, the society is largely involved in charity work. It not only provides financial support to medical and pharmacy schools but also plays a significant part in the advancement of medical research and in continuing post-graduate education.

5. The College of Arms, No. 130 Queen Victoria Street, EC4

Situated only moments away from the Millennium Bridge and St Paul's Cathedral, the College of Arms is hard to ignore with its imposing red-brick façade, impressive black iron gates and prominent coat of arms. The College, chartered by King Richard III in 1484, is officially known as The Corporation of the Officers of Arms in Ordinary and has been situated on this site for almost 500 years. The present building with its splendid courtyard facing Queen Victoria Street is Grade I listed and dates to the 1670s. It is one of only very few buildings of the period that still exist in the City of London and continues its original function as a repository for the country's heraldic, ceremonial, and genealogical records.

The College of Arms is the body that grants new coats of arms and maintains listings of royal licences, genealogies, flags, arms, and pedigrees. Its jurisdiction extends across England, Wales and Northern Ireland, as well as much of the Commonwealth.

The College is run by officers, the Heralds, who assist members of the public researching into their ancestry and who also bear responsibility for the organisation of many state functions such as the State Opening of Parliament, state funerals, coronation ceremonies and the Order of the Garter service held in June at Windsor Castle. When performing these duties, the Heralds are easily identified by their highly colourful and distinctive scarlet uniforms consisting of a tabard (a coat), embroidered with the Royal Arms in gold on the front, back and sleeves. The Heralds report to the Chief of the College of Arms, Earl Marshal, the Duke of Norfolk, whose office is hereditary.

The College of Arms is a popular film location and so may appear familiar. It was where in the 1969 James Bond film *On Her Majesty's Secret Service* Bond came

The College of Arms. (Alex McMurdo)

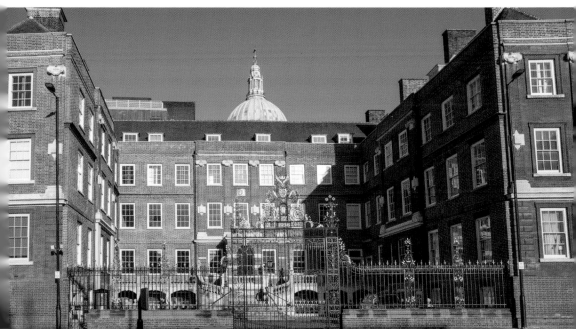

to research his rival Blofield's lineage in the hope of finding his Achilles heel. Guy Ritchie also used the exterior of the building as the home of Sir Thomas Rotheram in his 2009 movie *Sherlock Holmes* starring Robert Downey Jr and Jude Law.

www.college-of-arms.gov.uk

6. Wren's Churches, Queen Victoria Street, EC4

Queen Victoria Street stretches between Blackfriars station and Bank Junction. It is a long street with a mixture of old and new buildings that include offices, the College of Arms, the City of London School, as well as several religious buildings. Three churches, St Andrew-by-the-Wardrobe, St Benet's, Paul's Wharf, and St Nicolas Cole Abbey have existed here since the twelfth and thirteenth centuries, all rebuilt following their destruction in the Great Fire of London in 1666. Located metres apart from one another, they each bear the mark of their great architect, Sir Christopher Wren (1632–1723). Despite similarities they

St Andrew-by-the-Wardrobe. (Alex McMurdo)

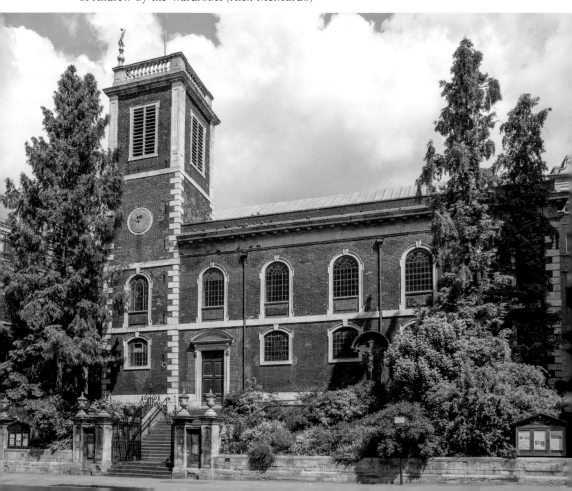

each have their own identities and differ in interior furnishings, shape and size. St Benet's was fortunate to have survived the Second World War unscathed but the other two churches were entirely gutted by enemy action and were the subject of meticulous restoration in the post-war years. Today, all three are designated Grade I listed buildings on account of their architecture, history, beauty and for their connection with Wren.

Since 1879 St Benet's has been London's Metropolitan Welsh Church and services here are conducted in Welsh. Built in the Dutch style and with a squarish

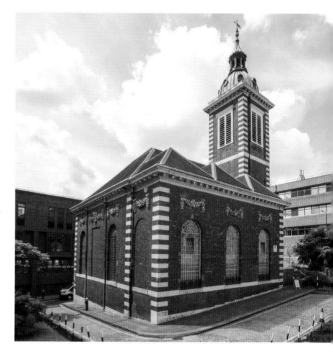

Right: St Benet, Paul's Wharf.
(Alex McMurdo)

Below: St Benet, Paul's Wharf.
(Alex McMurdo)

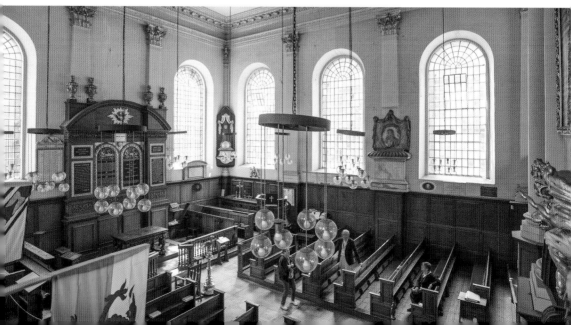

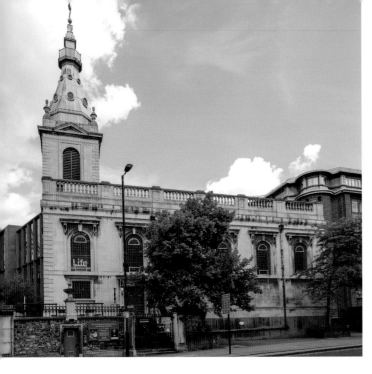

St Nicholas Cole Abbey.
(Alex McMurdo)

interior, it is completely different to St Andrew's-by-the-Wardrobe and St Nicholas Cole Abbey, which are both rectangular in form. St Benet's has a deep red brick and stone exterior and marvellous original furnishings including a pulpit, reredos and altar table, the work of master carver Grinling Gibbons. It has been the church of the College of Arms since 1556.

St Andrew-by-the-Wardrobe took its name from the king's wardrobe that was stored in the area for about 300 years (1361–1666). A handsome red-brick building, it was the parish church of Shakespeare when he lived and worked hereabouts in the early 1600s and there is a memorial to the celebrated playwright in the upstairs gallery.

Unlike the other two churches St Nicholas Cole Abbey is constructed from white Portland stone and characterised by its high balustrade, short tower and attractive lead covered spire. Its interior is the plainest of the three churches, but its stained-glass east window endows it with wonderful warmth and colour.

7. Guy's Hospital, Science Gallery and Cancer Centre, Great Maze Pond, SE1

Guy's Hospital was founded by Thomas Guy (*c.* 1645–1724), an extremely wealthy man and philanthropist who had made his fortune in publishing bibles and later through investments in the South Sea Company. He chose to site his hospital right beside Southwark's medieval St Thomas's Hospital, where he had been an active governor for many years. Guy recognised that those with contagious and incurable diseases, as well as those considered lunatics and the poor, were largely without access to medical treatment and on his death in 1724

bequeathed a sum of almost £240,000 to build a hospital where such patients could receive care and attention and the poor be admitted free of charge.

The two hospitals, St Thomas's and Guy's, have always had close ties. Until 1862 they worked alongside one another, but St Thomas's then moved to new premises beside Westminster Bridge, at which point many of its buildings were demolished. Nowadays Guy's is a large teaching hospital and is part of Guy's and St Thomas' NHS Foundation Trust, coming under the auspices of King's College London University. Guy's hospital has always been world famous for pioneering medical breakthroughs and in 2005 its surgical team carried out the UK's first live kidney transplant using a robot.

The hospital entrance on St Thomas Street leads into a large courtyard housing its original eighteenth-century hospital buildings including the chapel where Thomas Guy is buried, behind which are two quadrangles and an attractive cloister. The campus is now dominated by the thirty-four-storey Guy's Tower (1974), as well as the recent state-of-the-art Cancer Centre designed by Rogers Stirk Harbour & Partners (2016). The new award-winning centre has been extremely successful in combining Guy's and St Thomas's hospitals' oncology services under one roof and provides a highly flexible space where greater number of patients can now be treated.

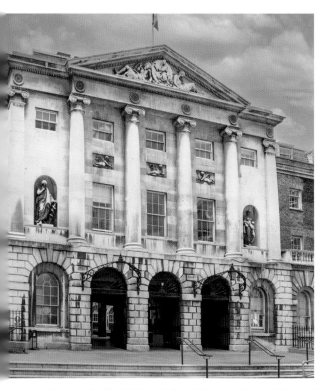

Above left: Guy's Hospital, St Thomas Street. (Alex McMurdo)

Above right: Guy's Hospital, cancer centre. (Alex McMurdo)

In 2018 a new public wing, Science Gallery London, opened on the campus as an interdisciplinary hub for discovery in health, science and art. Focusing in particular on young adults its aim is to encourage innovation in science through exhibitions, events, festivals and live experiments with scientific engagement at their heart.

www.london.sciencegallery.com

8. St George the Martyr Church, Borough High Street, SE1

Although today's building is less than 300 years old there has been a church at this junction on Borough High Street since at least the early 1100s, when Bermondsey Abbey was given permission to appoint the rector. Not much is known about the medieval church except that it was rebuilt at the end of the fourteenth century and was once again in need of repair by the 1600s. Having been constructed on unstable marshland, it is unsurprising that throughout its history St George the Martyr Church has been blighted with subsidence and has needed constant monitoring and attention. The present church, built between 1734 and 1736, is certainly one of Southwark's chief landmarks, with its large Portland stone tower and lofty octagonal spire. It is an impressive red-brick building and dominates the island upon which it sits. Designed by John Price in the classical style, it was funded with a grant from the Commission for Building Fifty New Churches, as well as monies donated by several City livery companies.

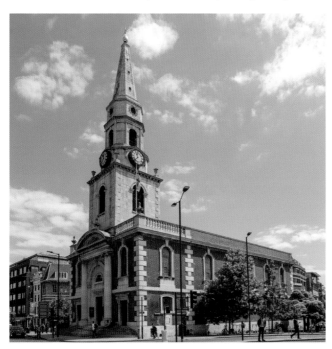

St George the Martyr Church. (Alex McMurdo)

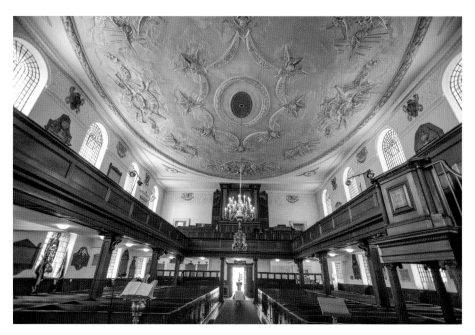

St George the Martyr Church interior. (Alex McMurdo)

The interior of the church is quite unexpected in that it has an unusual flat plaster ceiling, which was added in the restoration of 1897 by Basic Champneys and repainted in the 1960s. It is decorated in the Italian style and adorned with delightful cherubs descending through the clouds. The frieze above the galleries bears the crests of the Grocers, Drapers, Skinners and Fishmongers companies and the City of London, all benefactors of the church. It also displays the parish emblem the 'Southwark Cross'. In 1997 archaeological excavations revealed the remains of an earlier church, as well as evidence from the time of the Roman occupation.

St George the Martyr Church has a special relationship with the author Charles Dickens, who lived nearby in the 1820s while his father was imprisoned at the adjacent Marshalsea Prison. Knowing the church well Dickens used it as a setting in his book *Little Dorrit* (1857) and his heroine, who was both baptised and married within the church, is now depicted in Marian Grant's east window. Understandably many people refer to St George the Martyr as 'Little Dorrit's church'.

www.stgeorge-themartyr.co.uk

9. Hopton's Almshouses, Hopton Street, SE1

Since medieval times almshouses have been a feature of many towns and cities across the UK and were the main providers of homes for the elderly and poor before state pensions were introduced in the early 1900s. Although initially owned

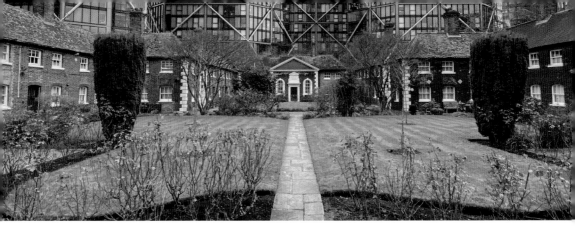

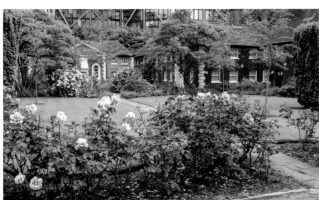

Above: Hopton's
Almshouses.
(Alex McMurdo)

Left: Hopton's
Almshouses.
(Alex McMurdo)

and administered by religious orders, many were sold off to private landowners
and later to the City livery companies after the Dissolution of the Monasteries in
the 1530s. The latter established 'hospitals' to cater for their needs and many still
offer this accommodation.

Hopton's Almshouses are now owned and managed by United St Saviour's
Charity and lie just behind Tate Modern. They consist of twenty historic dwellings
and have Grade II* listed status. A mix of flats and cottages, they are two storeys
high and arranged around beautiful gardens and a courtyard. They take their
name from their wealthy benefactor and founder, Charles Hopton (*c.* 1654–
1731), who made provision in his will for their construction. The almshouses have
been in continual use since 1752 but while they originally only housed single men,
they have since been modernised and residency is now open to women as well as
married couples. Today, prospective residents must be over sixty-five, on a low
income and be able to live independently.

10. Anchor Bankside and Anchor Brewery, SE1

The Anchor is the only one of twenty-two inns that lined the southern shore
of the Thames throughout the medieval period that remains in situ today and
is renowned for its wooden beams and labyrinth of small split-level bars and

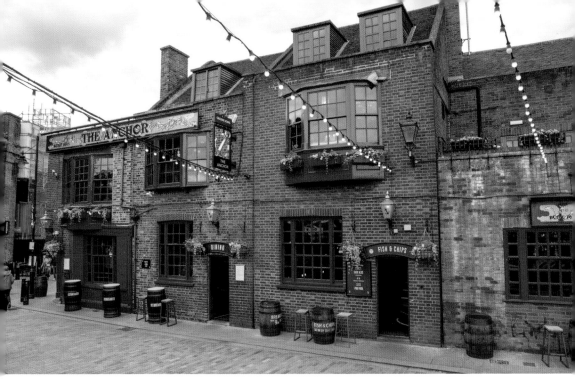

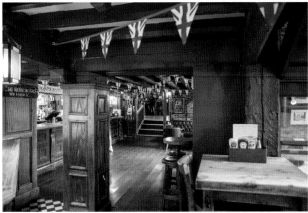

Above: The Anchor.
(Alex McMurdo)

Right: The Anchor.
(Alex McMurdo)

alcoves. The present building dates to the mid to late 1700s and still retains some of its original features including a kitchen fireplace and staircase as well as pine-panelling.

Although known as the Anchor from at least the late eighteenth century, it went under the name Castle on the Hoop in earlier times. In Shakespeare's day it was most probably used by the 'Winchester geese' as a stew or brothel and would have been popular with local sailors and actors as well as many customers from the City of London who were ferried across the Thames by boat.

Situated close to the Globe Theatre on the busy South Bank, the inn is itself a tourist destination especially as the pub is purported to be where the seventeenth-century diarist Samuel Pepys sat and watched the progress of the Great Fire of London in

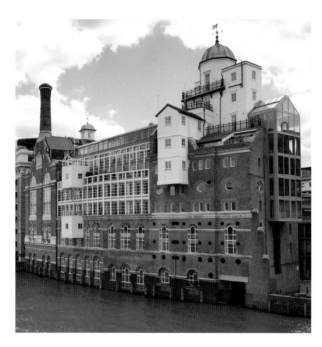

The Anchor Brewhouse.
(Alex McMurdo)

1666. In addition, the Anchor has great literary associations; the author of the first English dictionary, Dr Samuel Johnson, boarded at the inn, and it was here that he wrote his *Lives of the English Poets* (1781). He was great friends with Henry and Hester Thrale, the owners of the Anchor brewery situated a short distance from the inn in Park Street, and frequently attended a literary salon organised by Hester that included in its number Oliver Goldsmith, Edmund Burke, David Garrick and James Boswell. On Henry's death Johnson was appointed executor of his will and he and Hester organised the sale of the brewery to David Barclay for which Hester received £135,000. Under its new owner the Anchor brewery changed its name to Barclay, Perkins & Co. It expanded and went from strength to strength but eventually was purchased by the Courage brewery in 1955. Courage merged the Anchor with its Horselydown brewery on Shad Thames, renaming the entire business as the Anchor Brewery, until it finally closed its doors in the early 1970s.

www.greeneking-pubs.co.uk

11. The Imperial War Museum (former Royal Bethlehem Hospital), Lambeth Road, SE1

This grand building dates to 1815 when it was specifically built to house the inmates of the Royal Bethlehem Hospital, commonly known as 'Bedlam'. The original hospital established in the 1200s was run by a religious order dedicated

to St Mary of Bethlehem and looked after homeless people. In time it became an asylum for the poor, for those unable to care for themselves, and for the insane, and its nickname Bedlam, ultimately came to describe chaos and confusion. The hospital's previous home near Moorgate had all the marks of a tourist attraction bringing visitors from far and wide to gape at the mental patients – a place to visit like the Tower of London. This somewhat inappropriate practice continued here and was even encouraged by the hospital's governors as the tourists would often give donations after their visit.

The hospital's new facility was built to the design of James Lewis, the hospital surveyor, who based it on the plans of several architects, in particular John Gandy. Almost immediately the asylum proved to be too small so in 1835 Sydney Smirke was commissioned to build an extension. He achieved this by adding wings to each side of the main building (one to house the men, the other for women) and by constructing galleried blocks at the rear. He also replaced the low cupola above the main entrance with a higher dome, thereby increasing the size of the chapel beneath it.

Little else was to change before 1930 when the hospital moved, and the site closed down. Since 1936 the building has been occupied by the Imperial War Museum (IWM), the country's leading museum specialising in war and conflict. The IWM's magnificent collection of items includes documents, sound archives, film, oral histories, photographs, a large art collection and examples of significant military vehicles and aircraft. In the past decade the museum has launched some brilliant new

The Imperial War Museum. (Alex McMurdo)

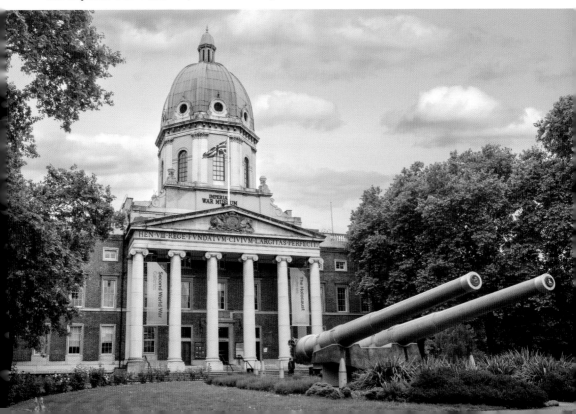

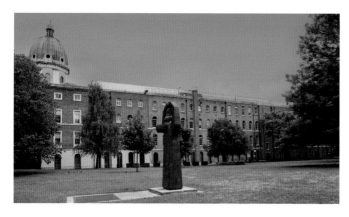

War Memorial
beside the Imperial
War Museum.
(Alex McMurdo)

galleries charting the history of the First and Second World Wars and has opened a most impressive and poignant Holocaust Gallery. The galleries, with their moving stories and artefacts, are highly acclaimed and certainly should not be missed.

www.iwm.org.uk

12. Old Vic Theatre, The Cut, SE1

The Old Vic is one of the UK's most historic and prestigious theatres much beloved by theatregoers. It opened in 1818 as the First Royal Coburg Theatre and has changed its name seven times in the intervening years yet has been known as the 'Vic' for much of its existence.

The theatre received Grade II* listing both for its stunning architecture as well as its historical importance as a key centre of ballet, opera, and serious drama in the twentieth century. Although the Old Vic has seen many modifications and renovations in its lifetime, its façade has not changed markedly from when it first opened and remains an icon at the junction of Waterloo Road and The Cut. Recognised now by its entrance canopy with slender iron columns, its frontage is memorable for its prominent and unusual broken pediment divided by a coat of arms.

Inside, the theatre boasts a host of beautiful features including its original ornate ceiling and horseshoe balconies full of moulded decoration. The design of the auditorium is undeniably that of J. T. Robinson, one of the country's first theatre architects, while the proscenium and boxes, although not original, were superbly restored in 1983.

Over the years the Old Vic has had many different personas ranging from pantomime and melodrama to music hall. In the early 1900s Lilian Baylis took over its management and introduced opera, ballet and drama – including all of Shakespeare's canon – which led to a complete turn round in the theatre's fortunes. She not only attracted a much wider audience but also laid the foundations for the future Royal Ballet and Royal Opera companies. During her administration John

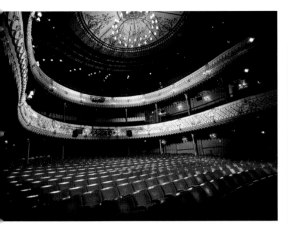

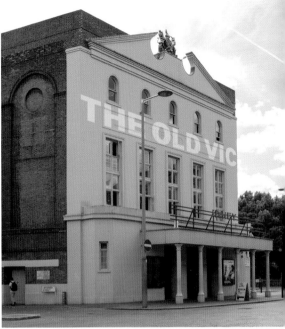

Above: The Old Vic. (The Old Vic Theatre)

Right: The Old Vic auditorium.
(Alex McMurdo)

Gielgud, Edith Evans Ralph Richardson, Sybil Thorndyke, Peggy Ashcroft and Laurence Olivier all performed here.

From 1950 the Old Vic became the temporary home of the National Theatre but when the National moved to its new South Bank home in the 1970s the theatre went into a period of decline. It has since managed to re-establish itself as one of the capital's major theatres under the artistic direction of initially Kevin Spacey (2003–15) and more recently Matthew Warchus.

www.oldvictheatre.com

13. The Old Operating Theatre and Herb Garret, No. 9a St Thomas Street, SE1

This is a splendid and unique museum that contains Britain's and possibly Europe's oldest surviving operating theatre in the attic of an eighteenth-century church. Delightfully atmospheric, it brings to life a time before anaesthesia when surgeons wore top hats and frock coats, and hygiene measures were not fully understood, the surgeons often operating without first having washed their hands!

The museum, located under wooden roof timbers is divided into two parts – the herb garret and the operating theatre. The former contains marvellous examples of a great variety of herbs used by the hospital apothecaries for medicinal purposes, including poppy seeds and wormwood. There are opaque and translucent apothecary's jars, skulls and skeletons and cabinets filled with

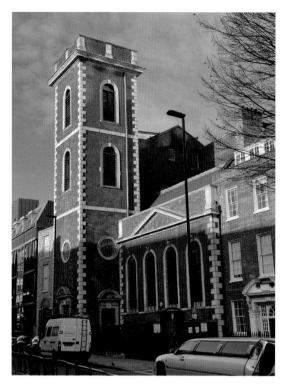

The Old Operating Theatre and Herb Garret. (Alex McMurdo)

surgical instruments. Perhaps of greatest interest to young visitors are the great assortment of gruesome-looking implements used by these practitioners including tourniquets, scalpels, and a fascinating array of saws.

In contrast, the operating theatre is a much brighter room and consists of an amphitheatre that has a narrow operating table in the centre. Students and apprentices would gather on four tiered stands to look at the proceedings below and they were a noisy crowd, shouting at one another to move so that they could be better placed to see the operation being performed. The patients (all from the women's surgical ward next door) would not only have to prepare for their coming ordeal, be it for an amputation, lancing of boils or perhaps trepanning, but also to being the focus of a large and unruly audience. Until 1846 all operations were conducted without the use of anaesthetics so surgeons could only offer patients comfort by giving them alcohol to dull the pain or by proffering them a stick to bite on. Most operations were successful, though many patients later died of infection, as no suitable treatment to counter this was available at the time.

When St Thomas's moved out of this site in 1862 the garret and operating theatre became disused and it was merely by chance that it was rediscovered almost a century later. Today's museum is really worth a visit and opens Thursday to Sunday between 10.30 and 17.00.

www.oldoperatingtheatre.com

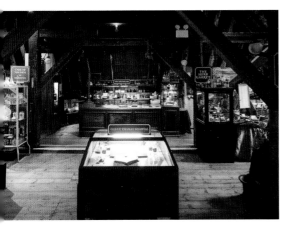

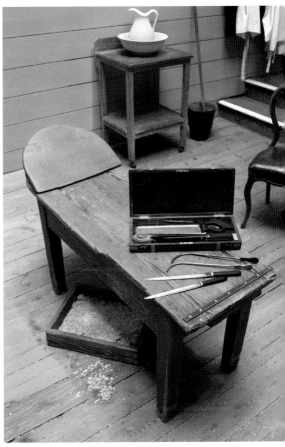

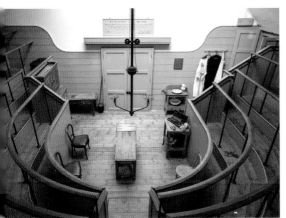

Top left: Herb Garret. (Old Operating Theatre and Herb Garret)

Above left: Operating theatre. (Old Operating Theatre and Herb Garret)

Above right: Operating table and instruments. (Old Operating Theatre and Herb Garret)

14. Leather Market Building and the Leather Hide & Wool Exchange, Weston Street, SE1

From medieval times Bermondsey was associated with the processing and trade of leather and hides. It was the perfect location for the leather industry as it was surrounded by open countryside with plenty of space for cattle to graze (from whom the hides were produced), had an excellent supply of water in the nearby tidal Thames and, moreover, a ready source of oak bark required in the tanning process. Leather making was decidedly the most unpleasant process as it produced foul odours from the dog faeces it used to soften the skins and was noisy too on

account of the steam engines needed to grind bark. However, the industry benefited from its proximity to the City of London, which provided a ready market for its goods, and due to Bermondsey's position south of the river it was not under the City's jurisdiction and so remained unaffected by the capital's stringent rules and regulations. During the industry's peak in the nineteenth century vast numbers were employed in Bermondsey's leather trade and it was second only to the docks in terms of the quantity of workers hired.

In 1833 a purpose-built leather market was erected on Weston Street, which became the centre of the trade for about a hundred years. Here, curriers and leather sellers purchased the local tanneries' merchandise and butchers' skins were sold to be processed for wool, leather and parchment. In 1878 the London Leather Hide & Wool Exchange was built alongside the leather market containing a large sales hall on the ground floor, a manager's apartment, and a pub where much business was carried out (nowadays operating as the 'Leather Exchange' on the corner of Leathermarket Street). A most attractive three-storey red-brick building with an interesting turret, the Exchange still displays a series of beautiful carved roundels portraying the stages of leather manufacture and selling.

Sadly, Bermondsey's leather industry declined throughout the 1900s as it battled with new production processes and competition from the newly established leather centres in northern England. The area's last working tannery closed in 1997 and the market buildings and Exchange were subsequently converted into workspaces used by start-ups and growing businesses.

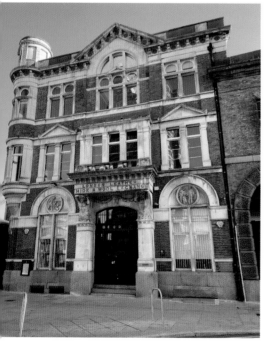
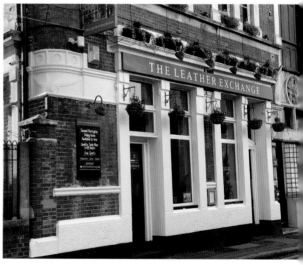

Above: The Leather Exchange public house.
(Alex McMurdo)

Left: London Leather Hide & Wool Exchange.
(Alex McMurdo)

15. London Bridge Station, SE1

Opened in 1836, London Bridge station is London's oldest railway station. It initially operated as a local service run by the London & Greenwich Railway (LGR). Built in the early years of the railway age, it later became a shared terminus used by rival companies. In time the line became so busy that it was necessary to increase capacity and the railway's viaduct had to be widened. Companies merged and by 1850 two separate termini with their own stations had been established on either side of the original station.

Passenger numbers continued to grow throughout the century and new lines were built to take the trains into the City and West End. In the 1920s Southern Railway took over management of the two termini and attempted to reunite them, but it was not until the latter part of the century that British Rail redeveloped the station. At this point London Bridge station acquired a new frontage, a bus station and concourse. More recently, the five-year Thameslink Programme (2013–18) has transformed the station. Grimshaw Architects received the commission to design a station fitting for the twenty-first century – one able to accommodate up to 90 million passengers a year. The project was massive, requiring the station to be kept open throughout all the different phases of construction. One of Grimshaw's partners described this: 'like performing open-heart surgery while the patient is jogging'.

London Bridge station, Tooley Street. (Alex McMurdo)

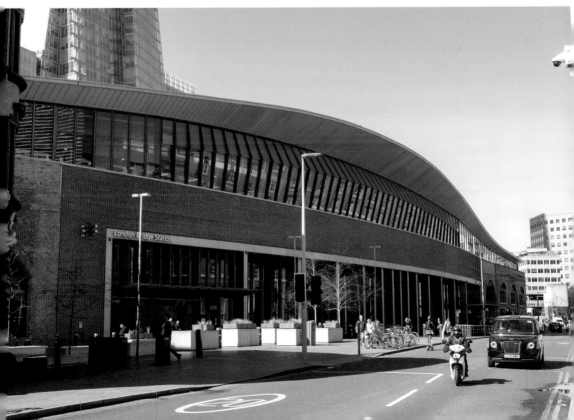

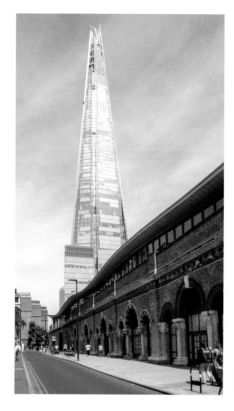

London Bridge station, St Thomas Street. (Alex McMurdo)

The upgraded station now has many more facilities including new entrances, long, covered platforms that accommodate twelve-carriage trains and the most spacious, lofty and bright concourse, reputedly the size of Wembley Stadium's football pitch. The changes allow more trains to run and to offer a much-improved service on the Thameslink line that connects with Gatwick and Luton airports, as well as the new Elizabeth line. Interestingly, since its makeover London Bridge station has grown in size, and is now as long as its neighbour, the Shard, is tall.

The station is really a destination in its own right with great shops, restaurants, bars and cafés, as well as a specially designed artwork, '*Me, Here, Now*', in its new public walkway, Stainer Street, by the English artist Mark Titchner.

16. Shad Thames and Butler's Wharf, SE1

Located adjacent to Tower Bridge on the south side of the Thames, Shad Thames and Butler's Wharf form part of the Tower Bridge Conservation area and are a marvellous insight into the area's industrial heritage. Running alongside the river, the narrow street of Shad Thames is characterised by its densely packed high warehouses that give it a canyon effect. During the nineteenth century Butler's Wharf (sitting directly beside Tower Bridge) extended from the riverside over an area of 25 acres inland and was home to the capital's largest group of Victorian warehouses. As you walk

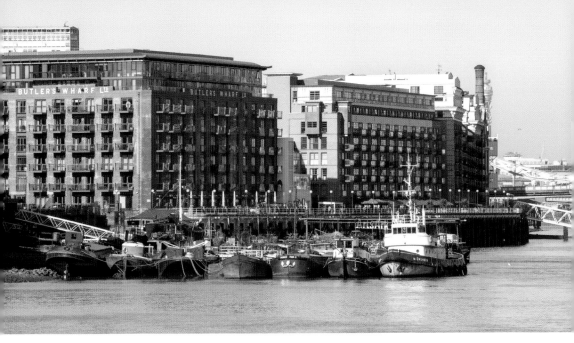

Above: Butler's Wharf. (Alex McMurdo)

Right: Shad Thames. (Alex McMurdo)

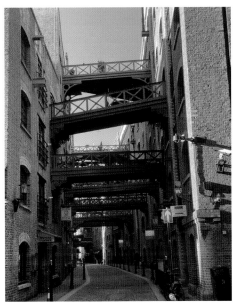

along Shad Thames now you see the buildings' metal walkways, gantries and hoists, all remnants of its former life. This would have been the liveliest of districts where stevedores and dockers worked endlessly unloading cargo into the warehouses lining the river. Later, using barrows they would wheel the merchandise across the walkways into the warehouses on the southern side of the street. The main cargo to arrive at Butler's Wharf was tea shipped from the Far East but there were many other imports of spices, sugar, rubber and grain too. Visitors walking in the area today will come across Cinnamon Wharf, Tea Trade Wharf, Saffron Wharf and Sesame Court, all names that reflect the cargoes once stored here.

Since the demise of the central London docks in the late 1900s the area has experienced a complete restoration. What were once disused warehouses have been converted into expensive luxury apartments and Shad Thames is filled with shops, cafés and restaurants. The major redevelopment was the brainchild of designer and restauranteur Sir Terence Conran (1931–2020), who had the foresight to renovate the neglected area. He established Britain's first Design Museum of mass-produced objects here, as well as a group of upmarket restaurants, bringing a much greater number of visitors to this side of the river. Perhaps this, as he claimed, laid the foundations for the greater transformation of Southwark's current riverside.

The Courage Anchor Brewery buildings in Butler's Wharf mentioned earlier in building 10 (the Boilerhouse, Brewhouse and Malt Mill) can best be seen from Tower Bridge where they dominate the skyline.

17. St Saviour's Dock and Jacob's Island, SE1

St Saviour's Dock and Jacob's Island are probably best known through the writings of Charles Dickens in his book *Oliver Twist* (1838). It is here at the edge of Shad Thames where Dickens' character Bill Sikes meets his death in the stinking mud while fleeing from an angry mob. Dickens provides a graphic description of this squalid slum area full of stench, overcrowding and dire privation. He describes the

St Saviour's Dock. (Alex McMurdo)

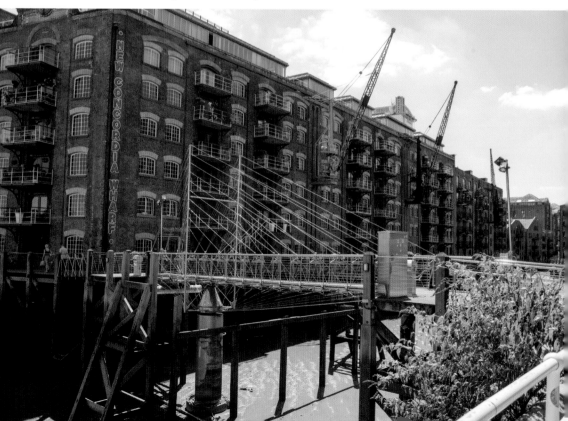

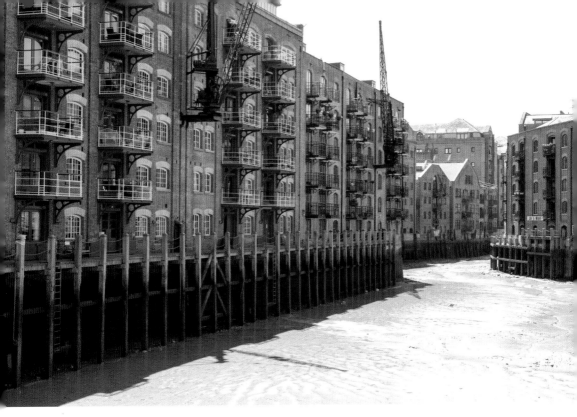

St Saviour's Dock. (Alex McMurdo)

quarter with its 'dirt besmeared walls and decaying foundations, every repulsive lineament of poverty, every loathsome indication of filth, rot and garbage: all these ornament the banks of Jacob's Island'.

St Saviour's Dock lies east of Shad Thames and is a tidal dock that takes its name from St Saviour's Church, around which Bermondsey Abbey was established in 1082. For 500 years its waters drove the abbey's mill and when the abbey closed in the 1530s the waters became a vital component in Bermondsey's tanning and leather industry. Nowadays, the attractive tall Victorian wharf buildings that border the dock have been converted into expensive residential apartments. Jacob's Island and the dock – once cut off due to the water inlet – are now reached via a pedestrian swing bridge that spans the basin's entrance.

18. Borough Market, No. 8 Southwark Street, SE1

Without doubt Borough Market is a foodies' paradise and a place not to miss. It buzzes with activity every day and purports to offer the very best of British and international foods – cheeses, meats, fish, fruit, herbs, oils and vegetables of every description, as well as many alcoholic beverages. Sited beneath the railway viaduct, the market has its own very special ambiance; noisy at times

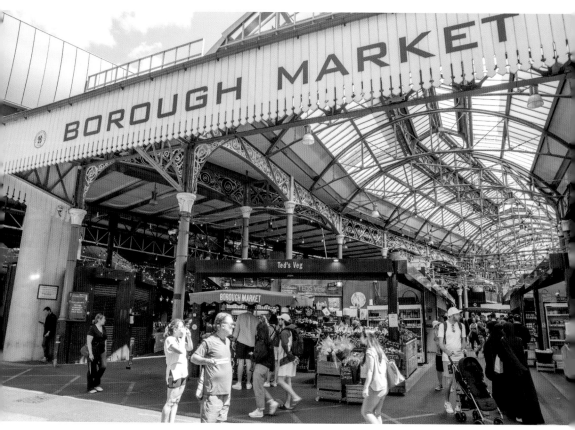

Borough Market. (Alex McMurdo)

when the trains thunder overhead, but surprisingly this does not detract from one's experience here. It is such a lively spot, full of colour and bustle, a place where market traders sell their specialist wares beneath the market's beautiful Victorian iron structure. The majority of the present buildings date to the mid-nineteenth century and nestle in the shadow of the medieval Southwark Cathedral (see building 1). The market itself is divided by small alleyways and roads and extends over three distinct areas: Green Market, selling small specialist produce; Three Crown Square, home to larger producers; and Borough Market Kitchen, the place to find interesting street food.

Borough Market is not a recent phenomenon. In fact, there has been a fruit and vegetable market in Borough for about 1,000 years. Originally, the market was held on Borough High Street, then the main road leading to the City of London via London Bridge, but it was such a busy thoroughfare that the market was forced to move to its current site in the mid-1700s.

The introduction of the railways in the early nineteenth century provided a great boost for the market as its traders could now easily access local foods transported from Kent and Sussex, as well as produce arriving by boat at Hay's Wharf. For

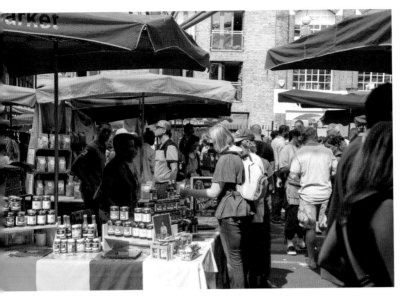

Above left: Borough Market. (Alex McMurdo)

Above right: Borough Market. (Alex McMurdo)

years Borough Market operated as both a retail and wholesale market, but in the late 1900s it changed direction to become a speciality retail food market.

Highly successful today, it is renowned worldwide for selling high-quality, sustainable food. Its excellent reputation along with the market's presence in many movies (including *Bridget Jones's Baby* (2016) and *Harry Potter and the Prisoner of Azkaban* (2004) have made it a number one destination on the itinerary of many tourists.

www.boroughmarket.org.uk

19. Bermondsey Street, SE1

Today Bermondsey Street is one of the capital's most trendy quarters lined with historic warehouses and narrow alleys that open out into courtyards behind. It boasts an eclectic selection of cafés, bars and restaurants and is moreover a cultural hub – visitors flock here to view contemporary art in Jay Joplin's 'White Cube Gallery' at Nos 144–152, to see stylish clothing at Zandra Rhodes' Fashion and Textile Museum (see building 45) and to learn about glassmaking and purchase signature glass pieces in Peter Layton's glassblowing studio at Nos 62–66.

Bermondsey Street has a history that stretches back to the medieval period when it was a simple path in the middle of the marshes surrounding Bermondsey

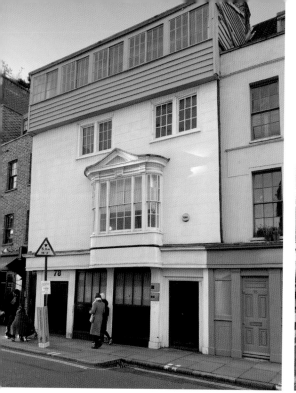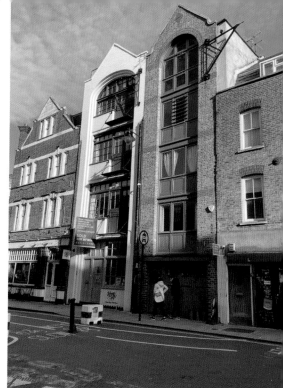

Above left: Bermondsey Street. (Alex McMurdo)

Above right: Bermondsey Street. (Alex McMurdo)

Abbey. After the abbey was demolished in the 1530s a large mansion was built here for Sir Thomas Pope (founder of Trinity College, Oxford) but both buildings have long since gone and modern-day Bermondsey Square now sits on the site of the inner courtyard of the former venerated Bermondsey Abbey.

Over time Bermondsey Street evolved from being a causeway into a street filled with shops, businesses, and houses. As industries grew in the vicinity more and more accommodation was needed for the district's ever-increasing population. Now Bermondsey Street displays a wonderful assortment of architectural styles and is celebrated for its original late seventeenth-century and eighteenth-century shopfronts and terraced housing, as well as its range of Victorian warehouses. The entire street is designated a Conservation Area and many of the buildings like No. 78, with its oriel window and weatherboarded upper floor workspace, have listed status. Such properties contribute greatly to Bermondsey Street's charm and help retain its feel of a village high street.

A quick walk around the area shows its connection with the leather and tanning industries reflected in names such as Tanner Street and Morocco Street. The street also has a great association with Christy & Co., the globally renowned hat and cap manufacturers. Based at No. 169, they were major employers of the area from the late eighteenth century and only moved away from Bermondsey Street and out of London in the early 1970s.

20. Hay's Wharf and Hay's Galleria, Tooley Street, SE1

What a breathtaking transformation from a derelict dock. In the late 1980s Hay's Wharf was immaculately reconstructed and given a spectacular glass and steel-barrel vaulted roof establishing Hay's Galleria, a shopping emporium. The original dock was sealed and bridged over at ground level, totally concealing what had once been a major river inlet where boats from all over the world had moored and unloaded their produce. Hay's Galleria is now filled with cafés, speciality shops and pop-up stalls. Its focal point is an awe-inspiring giant bronze 60-feet (18.3-metre) sculpture by artist David Kemp, labelled 'Navigators'. Looking like a ship, it contains a huge bronze fish head, towering mast booms, a telescope, and has a bizarre collection of moving parts, oars, and water jets.

Historically, Tooley Street was a working quay and from the early fourteenth century some substantial houses were located here. These eventually disappeared and for many years the street was filled with taverns, shops, and riverside businesses. Towards the end of the 1600s Alexander Hay opened a brewhouse right beside a small inlet of the river. He and his family ran their business here for almost 200 years during which time the site spread and became known as Hay's Wharf.

When Francis Theodore Hay died in 1838, his successor commissioned a new wharf around an enclosed dock that enabled Chinese tea clippers to unload their cargoes into the surrounding warehouses. Tea, however, was not the only commodity that arrived at the wharf. From the 1860s Hay's became renowned for pioneering refrigerated goods mainly from New Zealand and Australia. As the

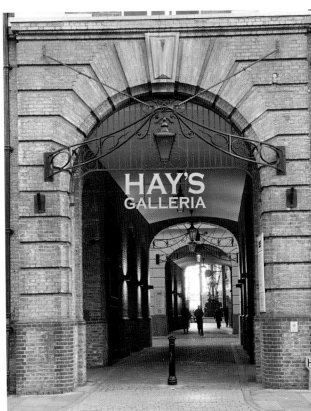

Hay's Galleria, Tooley Street.
(Alex McMurdo)

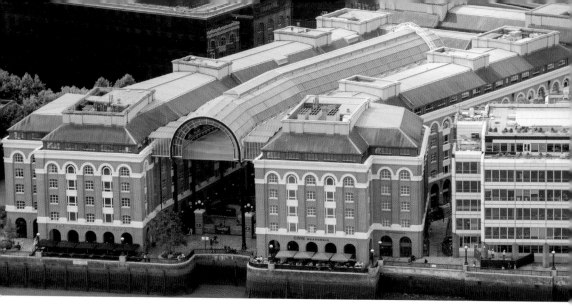

Hay's Galleria and Wharf. (Alex McMurdo)

prime storage area for dairy produce, as well as a multitude of other foodstuffs, it earned the nickname 'London's Larder'.

From the late 1800s Hay's Wharf's business flourished significantly so that the wharf ultimately stretched between London Bridge and Tower Bridge. Sadly, it suffered enormous bomb damage during the Second World War and although its buildings were restored in the aftermath of war, trade in the docks and wharves never recovered and had all but ceased by the 1970s. Hay's Wharf's subsequent 1980s restoration has revitalised both the dock and Southwark's riverside.

21. The Cockpit, No. 7 St Andrew's Hill, EC4

The Cockpit, located at the junction of St Andrew's Hill and Ireland Yard, is a striking Victorian pub. Easy to identify from its black and gold curved exterior decorated with tapering pilasters and large lanterns, it was built in the early 1800s, although there has been a tavern here since at least the sixteenth century. We know that the country's most famous bard, William Shakespeare (1564–1616), lived nearby in the early 1600s when he was a partner in the Blackfriars Playhouse. Records also show his £140 purchase in 1613 of a home in the nearby Blackfriars Gatehouse, although it is not known if he ever resided there.

As its name suggests the pub was initially a cockfighting venue until the practice was banned in the late 1830s. It was a cruel sport where spectators gambled and took pleasure from watching cockerels in a ring fighting one another to the death. Nowadays, the cosy pub interior is full of cockerel models and cock motifs and contains many features of a typical Victorian pub including wood panelling and leaded windows. Unusually there is a gallery above the bar, a place where cockfight spectators might well have stood in times gone by.

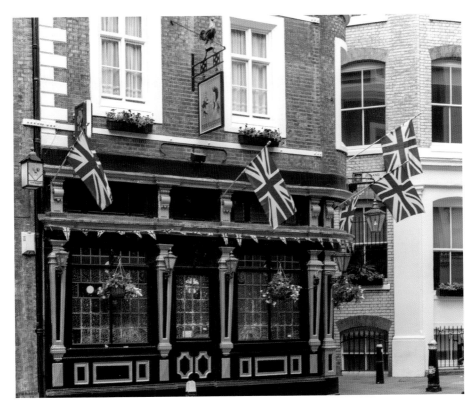

Above: The Cockpit. (Alex McMurdo)

Right: The Cockpit. (Alex McMurdo)

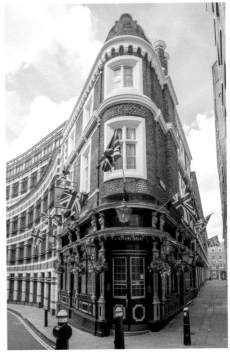

22. St Olaf House and Chamberlain's Wharf, Tooley Street, SE1

These two buildings sit side by side on Hay's Wharf and have formed part of the private London Bridge Hospital since 1986. St Olaf House lies closest to London Bridge and is easily recognised on its riverside by its ornate façade consisting of thirty-nine gilded and terracotta panels edged in black granite that surrounds six of its long narrow windows. The panels are by British artist and sculptor Frank Dobson (1888–1963) and contain illustrations of dockside life. The building was erected in 1931 as the headquarters for Hay's Wharf Company and is built on the

St Olaf House. (Alex McMurdo)

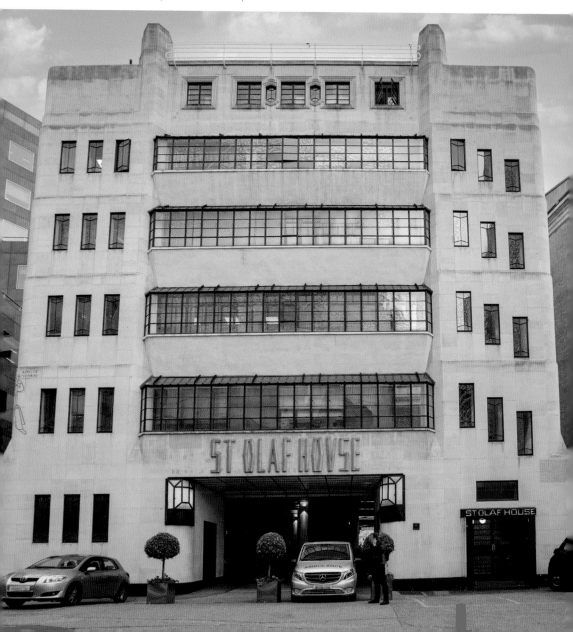

site of the former St Olave's Church. The company not only retained the name of the Norwegian King Olaf for their new premises (he had joined forces with Londoners in 1014 in their fight against the Danes) but also placed a figure of him on the Tooley Street building exterior. Look closely at the angled left-hand side of the building and you can see Olaf in black and gold mosaic, which is also the work of Frank Dobson.

St Olaf House was designed in the art deco style by Harry Stuart Goodhart-Rendel (1887–1963) in white Portland stone and carries Grade II* listing for its many attractive architectural features. It is six storeys high and has a wide central opening above which appear the words 'St Olaf House' in attractive gold lettering. Its entrance sits far back in a recess and visitors are greeted by its welcoming brightly coloured coat of arms and gilded 'Head Offices' inscription. The magnificent ornate bronze lanterns outside the entrance and the jagged iron railings surrounding the building continue the art deco theme. There is a wall plaque too that relates the story of St Olaf, taken from the church that had previously stood here.

Chamberlain's Wharf lies directly to the east of St Olaf House and was from at least the seventeenth century, one of a group of buildings and riverside storage facilities that existed here, but the current building was erected in the 1860s having replaced a former warehouse that was destroyed in the Great Fire of Tooley Street in 1861.

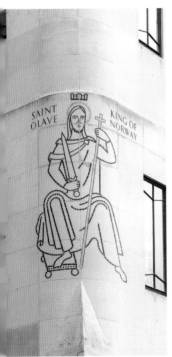

Above left: St Olaf House. (Alex McMurdo)

Above right: St Olaf House. (Alex McMurdo)

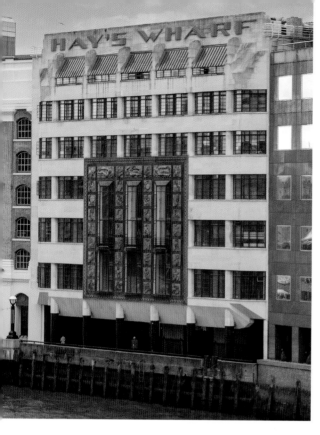

St Olaf House. (Alex McMurdo)

23. The Hop Exchange, No. 24 Southwark Street, SE1

It is impossible to ignore this white stuccoed building with its wonderful, curved sweeping exterior. Erected in 1867, it was designed by Victorian architect R. H. Moore and was built to be a market centre for hop trading. The Borough and neighbouring Bankside had both been associated with the brewing industry since the 1600s and as hops increasingly became a major part of the brewing process (giving the beer its bitter taste) the area developed into a major hub for the hop industry too. For years Londoners would spend their annual summer holidays working in Kent's hop gardens picking the ripe hop plants. Sadly, the practice ceased when hop picking was mechanised and hop pellets and hop essence replaced raw hops in the brewing process. These changes resulted in the death of the hop trade and by 1970 the area's hop traders and brewers had all moved away.

The Hop Exchange has a long front that stretches towards Borough Market (see building 18) and is covered with a wealth of interesting features: its façade is adorned with a series of cast-iron Corinthian half-columns, large windows, as well as a most ornate entranceway enhanced by highly decorated iron gates. In addition, the tympanum above the entrance is filled with splendid carvings depicting the work of hop gatherers. The building's magnificent interior consists of a vast trading hall with several galleries above. It has a particularly grand

Right: The Hop
Exchange entrance.
(Alex McMurdo)

Below: The Hop
Exchange interior.
(Alex McMurdo)

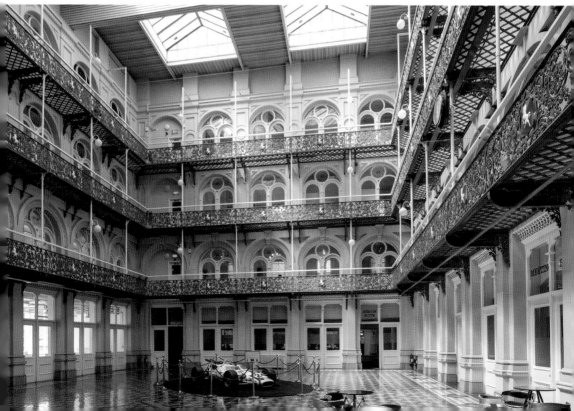

ambiance with its colourful orange floor tiles and striking bright green cast-iron balconies. The latter is further embellished by hop plant decoration and red plaques. The glazed roof above was purposely constructed to provide as much natural light as possible so that the traders could easily examine the hops when selecting which crop to purchase.

Originally the Hop Exchange was two storeys higher than it is today, but a fire in 1920 destroyed the roof and the upper floors. Now, the present owners of the building are proposing to restore it to its former splendour and size so the Hop Exchange, presently used as offices and as an events space, can offer more modern and higher quality space.

24. Menier Chocolate Factory, No. 53 Southwark Street, SE1

At No. 53 Southwark Street is the Menier Chocolate Factory, nowadays home to a theatre, café, bar, and art space. Built around the same time as the Hop Exchange, it is a rectangular building, five storeys high with curved corners and large windows. It is a handsome nineteenth-century warehouse with an interesting brick and stone bracketed cornice and still retains the original hoist bays on both sides. The warehouse was originally built as a chocolate factory for the famous French Menier Chocolate Company that had been founded in 1816 by Jean Antoine Brutus Menier.

Since 2004 the building has been home to one of London's most successful off-West End theatres and has won Olivier awards for its highly acclaimed productions of musical such as *Sunday in the Park with George* and *La Cage aux Folles*. Several of its productions have opened on Broadway where they too have been a great success. In its 180-seat auditorium the theatre stages a great variety of productions including musicals, live music, plays and stand-up comedy.

The Menier company began in Paris as a pharmaceutical business selling a selection of powders for medicinal purposes, but chocolate was later introduced as a medicinal ingredient to coat and disguise bitter-tasting pills. Within twenty years the company had greatly expanded its chocolate production and purchased a new production facility in Noisiel, just outside Paris. Increasingly successful Menier continued to expand and opened businesses in London and New York. The company was soon the largest French chocolate manufacturer but a lack of housing in Noisiel meant it was difficult to attract staff, so to encourage people to join the workforce Menier purchased land nearby the factory and built its employees accommodation, a school and town hall. The company prospered well into the twentieth century, but two world wars affected its production and by 1965 the Menier family was no longer involved in the company. Since then, it has changed hands several times and is now part of the Nestle Group.

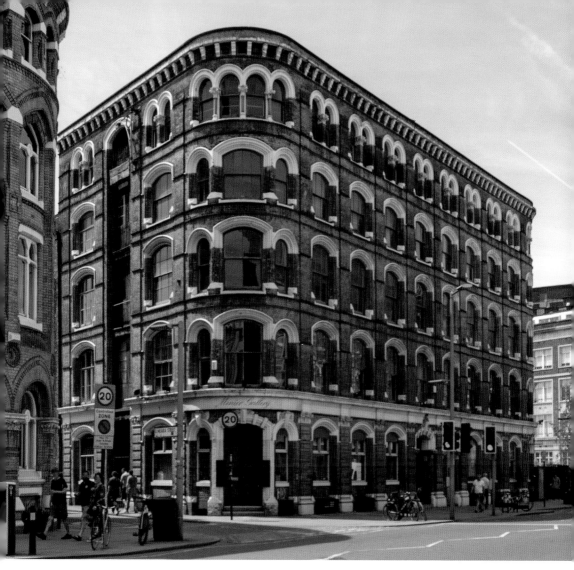

Menier Chocolate Factory. (Alex McMurdo)

Today, Menier's Noisiel factory is listed as a UNESCO World Heritage Site and Nestle's main French headquarters is based there.

www.menierchocolatefactory.com

25. The Blackfriar Pub, No. 174 Queen Victoria Street, EC4

A visit to Blackfriars would not be complete without a visit to the Blackfriar – one of the area's real gems. It is so utterly unique that it is no surprise that it appears in nearly every guidebook. The pub is located right beside Blackfriars railway station (see building 39) and is immediately recognised by its prominent, large statue of

a tubby monk. The 'Black Friar' proudly stands on the pub's rounded corner as though surveying the traffic that rushes past the busy road junction.

The pub, a wedge-shaped building only four storeys high, is surrounded by much taller and newer office blocks and nowadays looks somewhat incongruous in its setting. It faces out on to New Bridge Street and Queen Victoria Street and is impossible to miss with its fancy exterior that carries gold inscriptions 'Saloon Bar' and 'The Blackfriar' and is adorned with a deep mosaic fascia, as well as carved panels containing scenes of drinking and mischievousness.

The interior is even more astonishing – a delight of art nouveau design with wall friezes and figures that illustrate the antics of monks. In fact, the entire pub is full of jolly, fat friars, whether they are depicted in mosaic, copper bas-reliefs or in bronze, and rather than the pious beings one would expect, these monks are shown in activities associated with the joys of drink. In addition, there is a plethora of marble, wood, mirrors and stained glass that makes the Blackfriar stand out from all other pubs. With maxims such as 'Wisdom is Rare' and 'Don't Advertise, Tell a Gossip', engraved on the walls the pub is extraordinary. The back room (now a dining area) is equally as eye-catching with its elaborate marble vaulted ceiling.

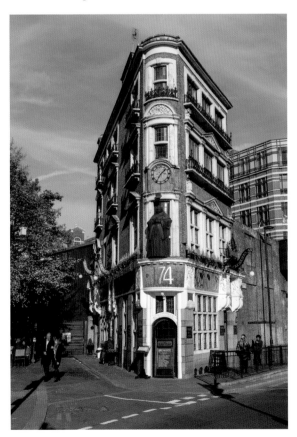

The Blackfriar interior.
(Alex McMurdo)

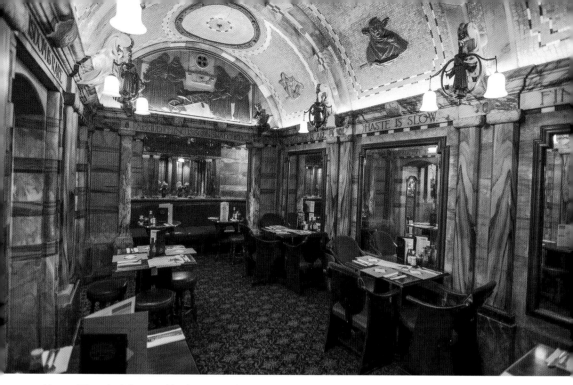

Above: The Blackfriar public house. (Alex McMurdo)

Below left: The Blackfriar interior. (Alex McMurdo)

Below right: The Blackfriar. (Alex McMurdo)

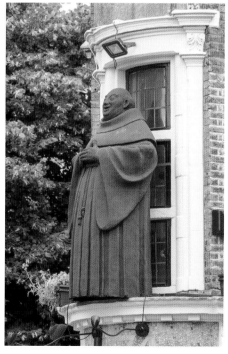

Although the Blackfriar opened in 1875, it underwent a complete renovation in 1902–05 and owes its present extravagant design and decoration to Henry Poole (1860–1919), who was a proponent of and key figure in the Arts and Crafts movement. His choice of the merry friars as a theme harks back to the Middle Ages when the Dominican Black Friars Monastery occupied the site and gave its name to the area.

www.nicholsonspubs.co.uk

26. The Mad Hatter Hotel, No. 3 Stamford Street, SE1

From at least the fifteenth century hat-making was a familiar industry in London and within a couple of hundred years it had become a well-established trade in this part of Southwark. In fact, by the 1800s there were at least seven hat manufacturers based along just this street. Despite the industry's presence here for so many years there is little now left to remind us of it apart from a street called Hatfields and The Mad Hatter Hotel and Pub on the corner of Stamford Street.

The handsome hotel building dates to 1875 and was originally part of the factory of Tress & Co., hat manufacturers. A family concern, Tress & Co. was located here for just over a century (1846–1953) and became internationally renowned. At this time hats were a common everyday accessory and Tress sold a great variety of styles including the ever-popular bowler, boater and top hats.

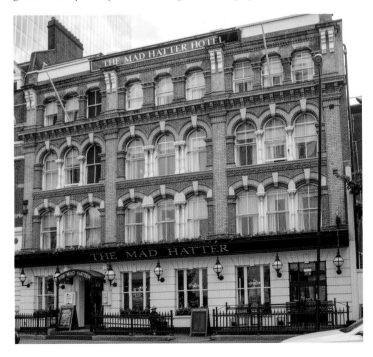

The Mad
Hatter Hotel.
(Alex McMurdo)

Nowadays, the Mad Hatter is a popular boutique hotel and pub. Its somewhat unusual title is attributed to a condition that afflicted hatmakers, supposedly due to the use of chemicals in the hatting process. Indeed, many people will be acquainted with Lewis Carroll's character, the Mad Hatter, in *Alice's Adventures in Wonderland* (1865).

www.madhatterhotel.co.uk

27. Tooley Street Fire Station, SE1

No longer a fire station, the building is currently home to a bar and restaurant, The Brigade Bar + Kitchen. It was opened just over a decade ago by chef Simon Boyle, who apart from setting it up as a dining venue established a charity, Beyond Food, to offer training to vulnerable people who had fallen on hard times. The charity's aim is to provide those who may be homeless, have certain mental health issues, a criminal record or perhaps an addiction, with the skills and experience necessary to work within the hospitality industry. The charity supports over 100 people each year to help them gain kitchen skills and ultimately attain meaningful employment. Through Beyond Food's programmes many individuals have acquired worthwhile skills and jobs and managed to overcome their lack

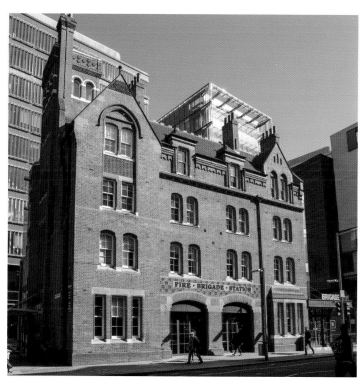

Tooley Street
Fire Station.
(Alex McMurdo)

of confidence or low self-esteem. The highly successful enterprise is supported by the international accounting firm PricewaterhouseCoopers (PwC), who own the building as well as the catering and food service provider, Baxter Storey, that provides the charity with administrative support.

The building itself was erected in the late 1870s and designed by the architect to the Metropolitan Board of Works, Alfred Mott. Attractively constructed in red brick with terracotta and sandstone dressings, it still retains its tower and original cart entrances. The fire station is one of a number that were built in the capital following the creation in 1866 of the Metropolitan Fire Brigade (MFB), the country's first public fire brigade. Five years earlier a major and devastating fire had broken out at Cotton's Wharf on Tooley Street that caused nearly the entire street and riverside to go up in flames. The blaze lasted two weeks during which time wharves, warehouses, riverside businesses, and Thames barges were utterly destroyed. In fact, the fire was so fierce it is considered as second only to the Great Fire of London in 1666 in its intensity and amount of destruction.

James Braidwood, who led the team fighting the fire, tragically became one of its victims. A small bronze statue of him is displayed within the restaurant and there is a memorial plaque remembering him on Cottons Lane.

www.thebrigade.co.uk

28. City of London School, No. 107 Queen Victoria Street, EC4

City of London School (CLS) is an independent day school for boys and owes its existence to a private Act of Parliament in 1834 and a bequest left in the fifteenth century by John Carpenter, Town Clerk of London. In its almost 200-year history the school has occupied three sites in the City of London, the most recent move in 1986 saw it become established on land lying between the north bank of the River Thames and Queen Victoria Street, across the river from Tate Modern and right next to the Millennium Bridge. Its present red-brick school buildings were designed by Thomas Meddings, a City of London architect and an old pupil (known as an Old Citizen). Despite its modernist style of architecture, the school blends in well with its seventeenth-century neighbours – the College of Arms and St Benet's Church (see buildings 5 and 6). In 2020 the City of London Corporation announced a competition for an upgrade of the school building that would see it become more sustainable and enable an increase in CLS's capacity. The winning architects put forward plans for an extension to improve connectivity between the different school departments, provide more learning space and introduce a new atrium. At present CLS has more than 950 boys aged 10–18 and is regarded as one of London's leading academic secondary schools.

When CLS first opened it was based in Milk Street, just off Cheapside. The school received praise both for its progressive and liberal philosophy (it accepted

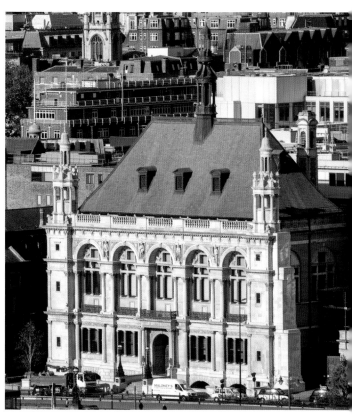

Right: Former City of London School. (Alex McMurdo)

Below: City of London School. (Alex McMurdo)

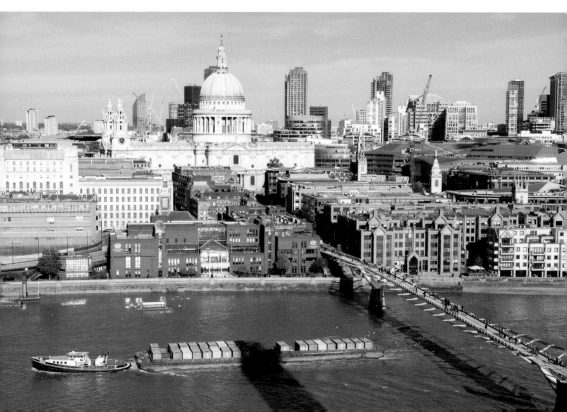

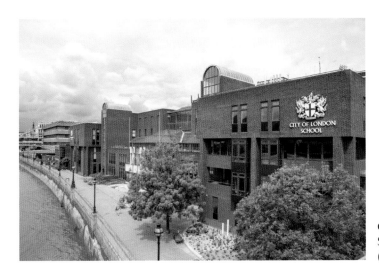

City of London
School.
(Alex McMurdo)

Nononformists and people of the Jewish faith), and for its broad curriculum that included debating, chemistry, mathematics, and a variety of modern languages. In time its pupil numbers grew significantly, causing it to move to a new building on the Victoria Embankment, where it remained for a century. Since the 1990s the former school has been occupied by the giant international financial services company J. P. Morgan.

As one would expect of a school of its calibre it has list of highly impressive alumni that includes, amongst others, Nobel prize winners, authors, lawyers, industrialists, scientists, engineers, musicians, academics, politicians, playwrights, actors and a prime minister, A. H. Asquith.

29. The Shipwrights Arms, No. 88 Tooley Street, SE1

This is a pub that really catches the eye both for its position at the junction of Tooley Street and Bermondsey Street and for its richly painted blue, cream and silver exterior. Sited right beside the entrance to London Bridge station (see building 15) and across the road from More London, it is a building that tourists and office workers pass by daily and is indisputably a prominent feature of the street.

The pub's crowning glory is surely the crouching caryatid that appears to hold up the window above its main round-arched entrance. Reminding one of a ship's figurehead, the caryatid with its outstretched arms dominates the building's exterior and introduces the Shipwrights Arms nautical theme. This is further continued inside the pub with paintings and artefacts of a marine nature as well as a superb painted tiled panel of shipbuilders at work on the wall by the left-hand door. The late nineteenth-century pub is Grade II listed, wood-panelled and consists of a main room with a central island bar.

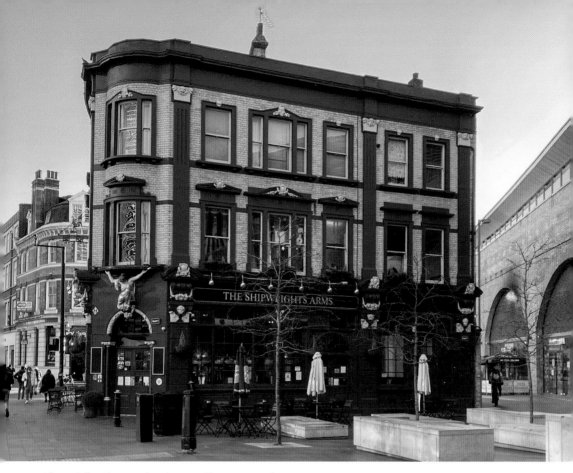

Above: The Shipwrights Arms. (Alex McMurdo)

Below left: Caryatid on The Shipwrights Arms. (Alex McMurdo)

Below right: Tile mural inside The Shipwrights Arms. (Alex McMurdo)

Tooley Street, being so close to the river, was once lined with inns and taverns but with modern development nearly all have been demolished or have been repurposed into residential accommodation and office space.

www.shipwrightsarms.co.uk

30. Octavia Hill Housing, Redcross Way, SE1

Octavia Hill (1838–1912) was born in Cambridgeshire and a product of James and Caroline Southwood Smith's marriage (James' third marriage having been widowed twice). Both parents had a keen social conscience, and this made a strong impression on Octavia from an early age. In 1840 following the financial crash her father was declared bankrupt and unable to cope or provide for his large family, her mother took a job in Holborn managing the Ladies' Guild, a co-operative crafts workshop. The family then moved to London where Octavia spent much time with her grandfather, Dr Thomas Southwood Smith (1788–1861). Working as a physician in the East End, he was an ardent supporter of public health reform and related first-hand his encounters with the terrible poverty, hardships, and social problems of the local population. It was at his house that Octavia met and mixed with intellectuals and other socially minded people, including the author Charles Dickens. Around this time, she also met John Ruskin, who became a good friend.

Octavia Hill housing. (Alex McMurdo)

Octavia Hill housing.
(Alex McMurdo)

Octavia was determined to improve homes for the working poor and managed to convince Rushkin to invest in her housing project (which he did for a 5 per cent return). She bought her first properties in Marylebone and her scheme was so successful that by 1874 she had fifteen similar schemes on the go. Excellent at publicising her work through articles and by networking, she gained financial backing from great philanthropists of the day.

By the 1880s Octavia was championing the need to provide not just decent accommodation but also communal facilities and public, green spaces (she ultimately became the co-founder of the National Trust), and her housing scheme in Redcross Way is a wonderful example of this. She had six attractive Arts and Crafts style cottages built and a community hall, and set them in their own gardens – the latter created to be an 'open air sitting room for the tired inhabitants of Southwark'.

Today Octavia Hill is remembered on a blue plaque on the community hall and by a striking 1896 mosaic roundel attached high on the wall of No. 54 Ayres Street overlooking the gardens.

31. LaLiT Hotel, Tooley Street, SE1

Since 2017 this historic Grade II listed building has been occupied by the LaLiT Hotel and is their first overseas outpost. The hotel is named after its founder, Mr Lalit Suri, and the company portfolio today consists of fourteen luxury LaLiT Hotels, Palaces and Resorts and LaLiT Traveller hotels in major cities across India.

The LaLiT company has utterly transformed what was previously a late Victorian school building into a sumptuous twenty-first-century boutique hotel and yet managed to retain much of its original character. Its bedrooms are called 'classrooms', and the Headmaster's Study with its ornate ceiling and enormous fireplace is now a wonderfully cosy lounge area open to all

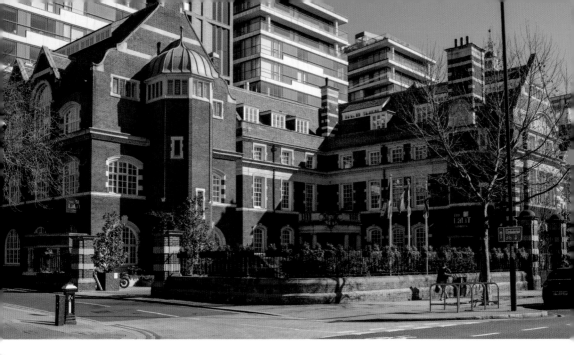

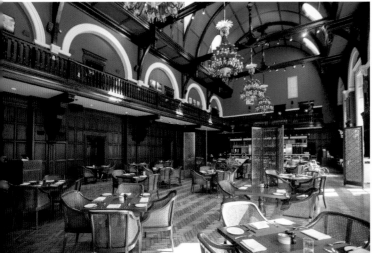

Above: LaLiT Hotel.
(Alex McMurdo)

Left: LaLiT Hotel restaurant.
(Alex McMurdo)

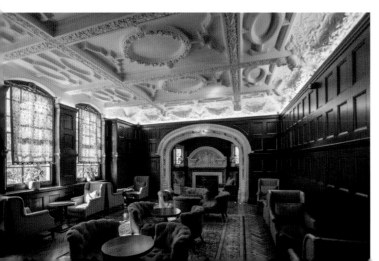

LaLiT Hotel Headmaster's
Study. (Alex McMurdo)

hotel guests. The former school hall has become the LaLiT's main dining area, renamed the Baluchi restaurant. This great hall is indeed the most exquisite space filled with original wood panelling at ground level and richly painted royal blue walls and ceiling above. To complete the atmosphere of utter luxury the hall boasts four stunning chandeliers that hang down elegantly from the vaulted roof.

Throughout the hotel the furnishings evoke the colour, opulence and style of India, especially in the bedrooms where satin and velvet are in abundance. The clever restoration has disguised former classrooms and transformed them into luxury accommodation.

The original building was designed in the Edwardian baroque style by E. W. Mountford (1855–1908), the architect of the Old Bailey. It opened in 1893 as St Olave's and St Saviour's Grammar School for Boys, a merger of two Southwark church schools that had existed since the sixteenth century. Constructed in red brick with white stone dressings, the building's flamboyant exterior displays a wealth of interesting features including Ionic columns, balustraded parapets, a lantern tower and clock and tympanums filled with carved figures of pupils learning. The grammar school moved away from London in 1968 when the premises were taken over by the South London College.

Former alumni of the grammar school include the novelist Lawrence Durrell (1912–90), the conductor, composer and organist William Cole (1909–97) and the Israeli politician and Ambassador to the UN, Abba Eban (1915–2002).

www.thelalit.com

32. Guinness Court, Guinness Trust Buildings, Snowsfields, SE1

During the 1800s Southwark experienced a great surge in population as new industries developed and people moved here to work. This naturally put a great stress on the housing market and many workers found themselves housed in sub-standard, unhealthy, and overcrowded conditions, sometimes with two families sharing just one room. The state took little responsibility and generally relied upon charitable organisations and philanthropists to offer the working classes better accommodation. American banker George Peabody (1795–1869), so appalled by London's slum conditions, had set up housing estates in the 1860s, made up of five to six blocks of flats, to provide clean and sanitary housing for the working poor. This model was subsequently followed by others.

In 1890 Sir Edward Cecil Guinness (1847–1927), head of the Guinness brewing firm, established the Guinness Trust to deliver decent homes for London's poor. Guinness Court with its conspicuous bright red-brick blocks and decorative interconnecting arches was built in 1897 and is still run by the trust (now the Guinness

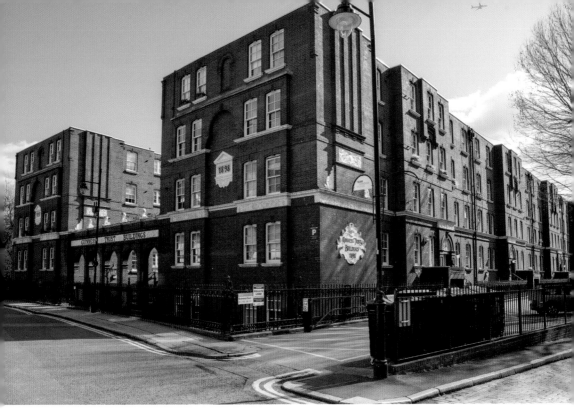

Guinness Trust Buildings. (Alex McMurdo)

Partnership Limited). From its inception the trust was keen to provide well-built and affordable homes for its tenants, such as seamstresses and labourers. Over a century on Guinness Court continues its founder's vision meeting essential housing needs.

33. The Dixon Hotel (Former Magistrates' Court and Police Station), Nos 209–211 Tooley Street, SE1

Built initially as the Tower Bridge Police Court, this grand-looking building was designed in 1906 by John Dixon Butler (1861–1920), a London architect much associated with the Edwardian baroque style of architecture. Dixon Butler took up the position of Architect and Surveyor to the Metropolitan Police in 1895 and spent much of his working life designing London's police stations and courts. Many of his buildings feature doorframes with highly ornate hoods and his Tooley Street police court is no exception. The building's red-brick and stone façade is filled with a host of extravagant details; at its apex a broken segmental pediment encircling the royal coat of arms and at street level, an imposing four-column entrance portico. These features together with the beautiful, curved balustrade above the main doorway, the keyed lintels, pediments, and multitude of windows all add to the building's grandeur.

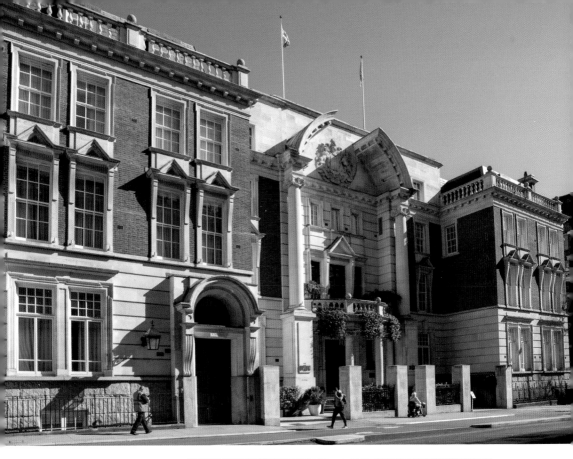

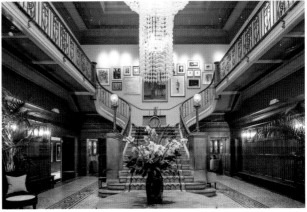

Above: The Dixon Hotel.
(Alex McMurdo)

Right: The Dixon Hotel.
(The Dixon Hotel)

Dixon Butler's work was largely influenced by the celebrated architect R. Norman Shaw (1831–1912), to whom he was apprenticed at the start of his career. The architects worked well together, and they collaborated on designs for New Scotland Yard in 1904.

Over time the Police Court developed into a magistrates' court and police station, comprising courtrooms, jail cells, a waiting hall, the police station, offices, and magistrates' quarters. In the 1970s the police station became one of several

bases for the Metropolitan Police's Flying Squad dealing with armed robberies but as happened to many of London's magistrates' and county courts in recent years the magistrates' court and the police station were closed, and the building was sold in 2013.

Acquired by the well-known Marriott hotel chain as part of its Autograph Collection, it is now called The Dixon, and the building has been transformed from its judicial and austere persona into a hospitable and welcoming place to stay. It has taken the original architect's name and much of the building's heritage has been retained. References to its former usage appear throughout the hotel. In fact, the first thing guests encounter as they enter the lobby is a chandelier made from old handcuffs, and the hotel's fine cocktails are served in its Courtroom Bar.

www.thedixon.co.uk

34. The Oxo Tower and Wharf, Barge House Street, SE1

Although not the tallest of buildings on the South Bank the Oxo Tower is a real icon and impossible to miss with its prominent O X O design on the tower's façades. Possibly best seen from the river or from the Victoria Embankment, one also gains great views of it from Waterloo and Blackfriars bridges.

The original building on the site was a power station built towards the end of the nineteenth century, supplying the Royal Mail with electricity. In the 1920s the Liebig Extract of Meat Company bought the site and then demolished many of the buildings, although they retained and enlarged the riverside front. They developed their new buildings in the art deco style and wanted to erect a tower to advertise their product, the Oxo Stock cube, but as there was a ban on skyline advertising at this time their planning application was rejected. To get around the predicament the company's architect, Albert Moore, came up with a clever solution – to build windows into the tower in the shape of two circles and a cross that would just coincidentally spell the name OXO and form an architectural feature. This tweaking of the regulations allowed the company to erect the tower, which has been dominating the skyline since 1929.

Nowadays the tower lies behind the eight-storey Oxo Tower Wharf, a mixed-use complex. The building not only contains low-rent cooperative housing but also has several galleries, design studios, specialist shops, cafés, and an eighth-floor restaurant, brasserie, and bar with fabulous views across the Thames. This all came about due to a campaign by local people in the 1970s to revitalise the neglected riverfront area and to provide facilities, shops, open spaces, and homes that would benefit the community. Having managed to stave off a proposed office development the campaigners finally purchased the 13-acre site from the Greater London Council in 1984. They established the Coin Street Community Builders

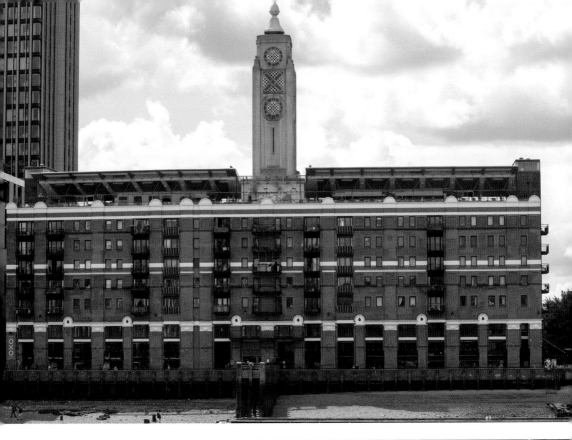

Above: The Oxo Tower and Wharf. (Alex McMurdo)

Right: Fire spinners in front of The Oxo Tower. (Alex McMurdo)

and redeveloped the site that now contains not only the Oxo Tower Wharf, but also a beautiful riverside park, the Bernie Spain gardens, a family and children's centre, sports pitches, and an arcaded riverside walkway.

www.oxotowerrestaurant.com

35. Unilever House, No. 100 Victoria Embankment, EC4

Unilever House was built in 1930 and designed to be the headquarters for the newly formed Unilever company following the merger of Lord Leverhulme's company Lever Brothers with the Dutch company Margarine Unie, two internationally renowned soap and margarine manufacturers. Ever since it was erected Unilever House, with its long, sweeping curved frontage clad in white Portland stone, has been a predominant feature of the Victoria Embankment. If you look closely, you will notice that the building's ground floor has no windows, designed on purpose to minimise the noise of traffic within the building. Its sweep of sixteen huge, Ionic columns between the fourth and sixth floors is particularly impressive, if not awe-inspiring. There are enormous sculptures too, the work of the Scottish born sculptor Sir Willian Reid Dick (1878–1961), that decorate the building on each of its side entrances. Entitled *Controlled Energy*, they contain massive pairs of horses being restrained by powerfully built figures – female facing the Thames and male on the building's New Bridge Street side.

Left: Sculpture on Unilever House. (Alex McMurdo)

Below: Unilever House. (Alex McMurdo)

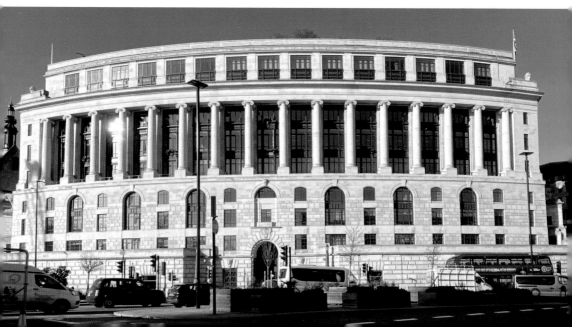

The exterior façade has largely stayed the same since it was first built. However, there have been major alterations inside, the most recent having taken place in the early 2000s, to the designs of Kohn Pedersen Fox. As Unilever House has listed status the firm worked closely with English Heritage and the City of London Corporation in drawing up its plans that led the demolition of much of the building's internal structure. After seventy-five years the original office layout had outlived its use. It was felt that the lack of access to Unilever House's wonderful panoramic views, the cramped conditions, and the location of the staff restaurant in a windowless basement were concerns that needed to be addressed in the building's redesign. The modernisation of the building has resulted in the creation of the most stunning glass atrium with glass lifts and bridges. This not only fills the building with light but also encompasses suspended platforms for breakout space. The staff restaurant is now placed on the top floor and along with the newly created roof garden offers staff and visitors alike excellent views of the Thames.

36. Faraday Building and Baynard House, Queen Victoria Street, EC4

Faraday Building and Baynard House sit almost opposite one another on Queen Victoria Street. Although very different in architectural style, they have one thing in common – telecommunications – and both buildings are occupied by the BT Group.

Faraday Building, named after the English scientist Michael Faraday (1791–1867), is made up of two white stone blocks, the lower one having been built in 1890 as a Post Office Sorting Office, while the taller central building with turrets is a product of the early 1930s. When the latter was opened it was the cause of great concern and controversy as it had obscured sight of St Paul's Cathedral from the river. As a result, by-laws and planning regulations were introduced to protect sight lines of the cathedral, which explains why all other buildings in the vicinity, like Baynard House and the City of London School, are today restricted in height. By the 1930s the Faraday Buildings were extremely important, used not only as London's main telephone exchange but also housing the world's first International Telephone Exchange. If you look above the second-floor windows there are some interesting carvings of items associated with telecommunications such as a telephone, cables and switching equipment and above the building's main doorways the symbol of the caduceus (a staff with wings above two coiled snakes) of Mercury is displayed.

In total contrast to the Faraday Building, Baynard House is a typical brutalist structure of the late twentieth century. It has a plain concrete exterior and like the Barbican Estate of the same period has raised pedestrian walkways that separate pedestrians from the traffic and street. Since 1980 an unusual sculpture by Richard Kindersley has decorated its first-floor courtyard. Called the *Seven Ages of Man*, it is a striking column with carved faces representing all life's stages from babe to dotage and death.

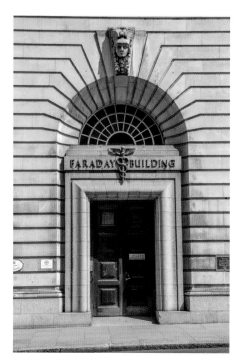

Above left: The *Seven Ages of Man* sculpture, Baynard House. (Alex McMurdo)

Above right: Faraday Building entrance. (Alex McMurdo)

Below: Baynard House. (Alex McMurdo)

Baynard House occupies the site of the former Baynard's Castle (the foundations of which is now a designated scheduled monument) from which it gets its name. The building today is the capital's largest telephone exchange providing ultra-high-speed broadband to many of the City of London's banks and financial organisations.

37. Tate Modern, Bankside, SE1

Built within a redundant mid-1900s power station, Tate Modern first opened its doors in May 2000 exhibiting present-day and international modern and contemporary art. Since its appearance on the art scene, it has had attracted visitors from all across the globe and has continually been one of London's most visited tourist sites. It is a massive brick-built structure with a tall prominent chimney at its centre that makes it instantly recognisable. Situated at the southern end of the Millennium Bridge, it is easily reached from the City of London and a convenient location for visitors walking beside the river on the South Bank.

Apart from exhibitions all visits to the gallery are free. Tate Modern opens daily and displays many exciting artworks in areas divided into Performer and Participant, Artist and Society, Materials and Objects, Media Networks and In the Studio. Its collections that include works of artists as diverse as Picasso, Jenny Holzer and Emily Kame Kngwarreye are spread over two buildings – the original Natalic Bell Building dominated by the giant turbine hall, and the more recently built Blavatnik Building. The latter, pyramidal in shape, complements the main building in its colour of brickwork and is itself a work of art. The underground Tanks gallery occupy this building, and this is where many video works, installations and performances take place.

Tate Modern. (Alex McMurdo)

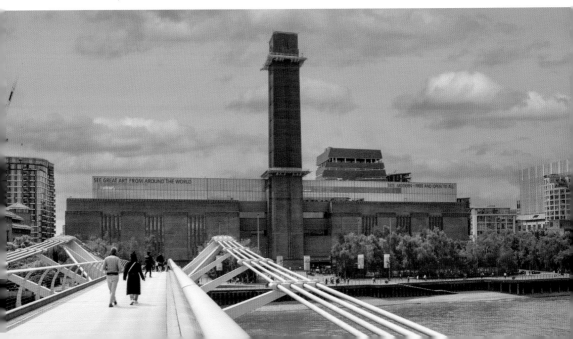

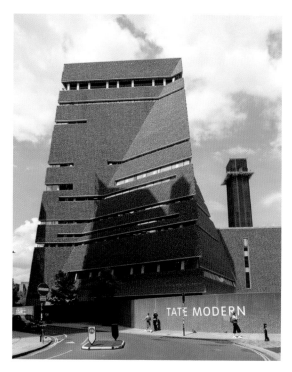

Tate Modern Blavatnik Building.
(Alex McMurdo)

In the two decades since Tate Modern was launched the turbine hall has played host to regular sponsored installations. These have included Louise Bourgeois's enormous giant steel spider, Ai Weiwei's hand-crafted one hundred million ceramic sunflower seeds, Doris Salcedo's, *Shibboleth* that consisted of an unsettling crack along the length of the turbine hall, and most recently Anicka Yi's, *In Love With the World* that saw jelly fish shapes floating around the hall.

Tate Modern is one of four Tate Galleries in the UK today and developed out of Britain's Tate Gallery, established by the sugar magnate Henry Tate in 1897. Nowadays most of the Tate's contemporary art is in Tate Modern while Tate Britain (the original Tate Gallery) displays the national collection of British Art from 1500, as well as international contemporary artworks.

www.tate.org.uk

38. The Young Vic Theatre, The Cut, SE1

Situated halfway along The Cut not far from the Old Vic (see building 12), the Young Vic was built in 1970 on a Second World War bomb site, once the location of a butcher's shop. Although the building was constructed on a shoestring, its 450-seat auditorium was extremely versatile and much loved by its audiences. Built from concrete breeze blocks, the theatre was originally designed as a

temporary structure expected to have a life of about five years. Even though it far outlived this forecast, by the early 2000s it became obvious that the theatre was in dire need of renovation. So, from 2004 to 2006 the Young Vic closed while the building, redesigned by the architects Haworth Tompkins, was refurbished. No changes were made to the main auditorium apart from some technical upgrades, but two new studio theatres were created, as well as dressing rooms, workshop spaces and a stunning double-height restaurant and bar area. As a result of its refurbishment the theatre received the 2007 RIBA London Building of the Year Award.

When the Young Vic launched in 1970 as an offshoot of the Old Vic it was intended to be a theatre that would cater for a young, fresh audience and offer affordable tickets. It was Frank Dunlop, the theatre's first Artistic Director who was set on providing a new form of theatre, more on the lines of what we consider as fringe or alternative today. Dunlop was passionate about introducing live theatre to the young people of the area and skilfully provided a wide repertoire that included classic and innovative plays. The theatre became independent in 1974 and its reputation for high-quality performances and for attracting the best names, playwrights and producers has been a major feature of its existence ever since. The Young Vic has gone from strength to strength, continually pushing the boundaries and always staging bold and pioneering works. Kwame Kwei-Armah, the theatre's present Artistic Director, has continued to forge Dunlop's

The Young Vic main entrance (former butcher's shop). (Alex McMurdo)

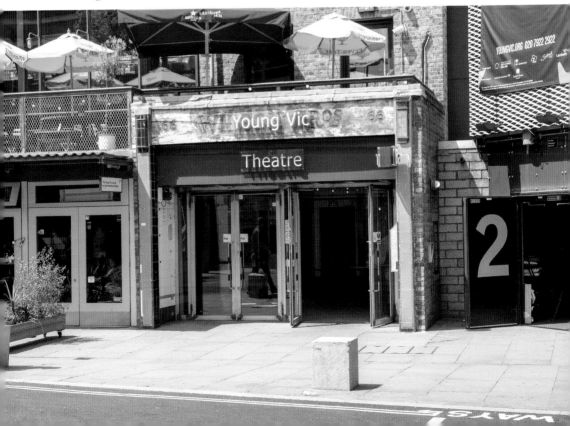

The Young Vic.
(Alex McMurdo)

The Young Vic foyer
café and terrace.
(Alex McMurdo)

original vision and has extended the theatre's range of productions to cover more social and multicultural themes, in such a way representing the diversity of present-day London.

www.youngvic.org

39. Blackfriars Railway Bridge and Station, No. 179 Queen Victoria Street, EC4

The first railway bridge across the Thames at Blackfriars was built in 1864 by the London, Chatham & Dover Railway (LCDR), and initially trains ran between south London to stations in the City and King's Cross. Although first based on the south side of the river, the station was moved to the north bank a couple of years later when a new St Paul's station was opened, following the construction of St Paul's Railway Bridge. The station ultimately changed its name from St Paul's to Blackfriars in 1937, differentiating itself from the tube station of that name and has been known as Blackfriars ever since. For many years the station provided

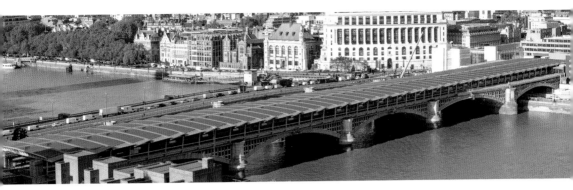

Blackfriars Railway Bridge and station. (Alex McMurdo)

the terminus for rail trips to continental Europe, just like St Pancras International does through its Eurostar service today. Astonishingly a wall of the station that contained the names of its fifty-four overseas destinations (featuring places such as Turin, Lucerne, Cologne and St Petersburg) survived wartime bombing and is now located in the present station's ticket hall area. It is interesting not purely for the variety of towns it covers but also because it is a work of art with each place name carved in gold leaf onto individual blocks of sandstone.

Blackfriars station today is operated by National Rail and Thameslink trains run through the station connecting England's south coast to Cambridge and Bedford in the north. The line also importantly serves two of London's main airports at Gatwick and Luton. In 2009 Thameslink embarked upon a major redevelopment programme to modernise and increase the line's capacity. This has resulted in the construction of a new station entrance on the South Bank just beside Tate Modern and means that Blackfriars, unlike any other London station, now has entrances on both sides of the river. Since the refurbishment the upgraded station has

Blackfriars station northern entrance. (Alex McMurdo)

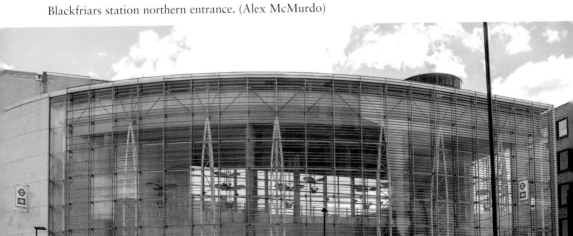

platforms that accommodate longer twelve carriage trains, and this has led to a greatly improved and frequent service. Blackfriars station has also benefited from its new roof; with 4,400 photovoltaic panels it provides the station with about half of its energy and professes to be the world's largest solar-powered bridge.

40. Doggett's Coat and Badge, No. 1 Blackfriars Bridge, SE1

Doggett's Coat and Badge is an extremely popular pub that sits beside the river at the southern end of Blackfriars Bridge. It is not one of Southwark's ancient hostelries but dates to the late twentieth century. Along with the adjacent block of flats and the nearby Southbank Centre and National Theatre Doggett's was built in the post-war period and is characterised by its grey monochrome unpainted appearance. Known as the brutalist style of architecture (from the French phrase *beton brut*, meaning 'raw concrete'), the design has always been controversial mainly due to its use of exposed concrete and its minimalist construction with little, if any, decoration. Although its exterior may not be to everyone's taste, Doggett's interior is both warm and welcoming. The pub is arranged on several floors and serves good pub food and quality cask-conditioned beers. Perhaps its piece de resistance is the roof terrace with excellent views across the river of the Inns of Court, St Paul's Cathedral and Somerset House.

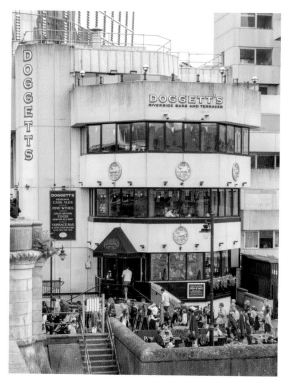

Doggett's Coat and Badge.
(Alex McMurdo)

Although the pub is relatively new its name has a long and fascinating history. Thomas Doggett was a seventeenth-century Irish actor who came to fame on the London stage. Legend states that he fell overboard while being conveyed across the Thames in a small boat and was brought to safety by a waterman. In gratitude he established what is now the oldest annual rowing race in the world, Doggett's Coat and Badge. Whether the story has any truth is unknown, but the first race was held in 1715 (just after George I came to the throne) and covered a 4-mile, 5-furlong (7.44-kilometre) course on the Thames between London Bridge and Cadogan Pier, Chelsea. On Doggett's instructions six young watermen were to compete in the race, and the winner would receive a red waterman's coat decorated with a silver badge inscribed with the word 'Liberty' in honour of the accession of George I and decorated with a horse, the symbol of the House of Hanover. Since Doggett's death in 1721 the Fishmongers' Company along with the Watermen and Lightermen Company have run the annual race in accordance with its founder's instructions.

www.nicholsonspubs.co.uk

41. The Circle, Queen Elizabeth Street, SE1

This is an exceptional and highly unusual housing scheme developed in the late 1980s and an illustration of post-modern architectural design. The work of the architectural practice CZWG (Campbell Zogolovitch Wilkinson and Gough), it received Grade II listing for being, in Historic England's words, 'a bold landmark development in the regeneration of Docklands'. It is certainly the major focal point of Queen Elizabeth Street with its four curved cobalt-blue glazed brick apartment blocks, two on either side of the street, and explains why the development was

Jacob the dray horse in The Circle. (Alex McMurdo)

named The Circle. The bright blue exterior references the nineteenth-century paint and dye works that was once present in the district and the large bronze horse in the centre of the circus, placed between the two halves of the apartment blocks, reminds us of the area's association with the Courage Brewery.

Named 'Jacob – the Circle Dray Horse', it is the work of the sculptor Shirley Pace (1987). Enormously heavy, it was brought here by helicopter and placed as a centrepiece to commemorate the work of the dray horses whose job was to deliver Courage beer around London from the brewery on nearby Horslydown Lane and were stabled on this site from the early nineteenth century.

42. The Globe Theatre and Sam Wanamaker Playhouse, Bankside, SE1

The Globe Theatre is located to the east of the Millennium Bridge on Bankside and is adjacent to Tate Modern (see building 37). The theatre opened in 1997 to great acclaim and it is a magnificent reconstruction of the original sixteenth-century playhouse. Prior to its construction an enormous amount of research was undertaken to ensure that the replica theatre would be as authentic as possible. So, it was built using the techniques and materials of the Elizabethan age with green oak and wooden pegs to fix the timbers together, and only partially covered with a thatched roof (the first to be built in London since the Great Fire of London in 1666). The building looks like a big 'O', is three storeys high and spectators either sit on the tiered wooden benches or stand in the pit close to the main action of the play. In Shakespeare's day those who stood in the yard were called groundlings and were renowned for their often noisy and bad behaviour. The players performed to packed audiences, perhaps as many as 3,000 spectators. In contrast, today the theatre has capacity for about half of this number, with room for only 700 standing in the pit.

It was the American actor and film director Sam Wanamaker who campaigned relentlessly to rebuild Shakespeare's Globe Theatre and his dream took twenty-five years to materialise. The present Globe Theatre is located just a short distance from its original site on Bankside, right beside the Thames, and stages plays during the warmer months between April and October. Although many of the productions are Shakespearean plays the theatre also produces new works and those written by some of the bard's contemporaries. The theatre is moreover a cultural and educational centre that offers guided tours and educational workshops throughout the wintertime.

Since 2014 when the Sam Wanamaker Playhouse was opened alongside the Globe Theatre, theatregoers have had the opportunity to see more productions throughout the year under cover. Modelled on the candlelit theatres of Shakespeare's London, the playhouse has a glorious Jacobean interior that is a most intimate and atmospheric space.

www.shakespearesglobe.com

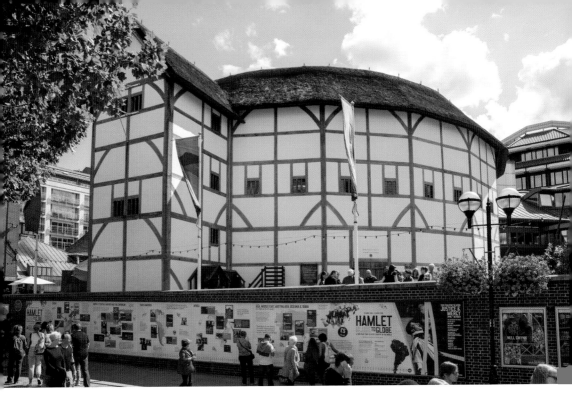

Above: The Globe Theatre. (Alex McMurdo)

Right: Sam Wanamaker Playhouse. (Alex McMurdo)

43. Old Union Yard Arches and the Jerwood Space, Union Street, SE1

Union Street has in recent years become one of Southwark's bustling quarters full of great culture and interesting architecture. It is home to theatres, a performing arts complex, galleries, pubs and cafés, as well as some excellent restaurants. At the western end of the street beside the railway viaduct is an iron sign welcoming visitors to 'Old Union Yard Arches'. On entering the courtyard it soon becomes

obvious that this is a gentrification of what had previously been a rather run-down site. Now the double-height railway arches are smart glass-fronted units occupied by a mix of organisations. Two fringe theatres, the Union and Cervantes, have moved in here. The Union Theatre, which was formerly situated in a warehouse across the street, has now increased its space and has much improved facilities. Every Sunday it is filled with young local kids who come here to receive the training and skills to work in the theatre and performing arts sectors. Further along the passageway the Cervantes Theatre specialises in Spanish and Latin American plays and puts on performances in both Spanish and English. Intermingled with the theatres are several quality restaurants (the Italian, Macellaio and Israeli, Bala Baya), as well as Flying Fantastic, a company that specialises in aerial fitness. At the far end of the passageway the Africa Centre has taken over a couple of units and recently opened its new purpose-built centre, Gunpowder House, in a renovated building facing the arches.

Walking east along Union Street is another arts complex, Jerwood Space, that was set up in 1998 by its parent organisation, the Jerwood Foundation. Occupying a refurbished Victorian school, it now functions as a rehearsal facility for dance and theatre companies, an art gallery and exhibition space. The former school halls have become rehearsal spaces and many established theatre and dance professionals use these facilities daily.

Above: Sculpure outside the Africa Centre. (Alex McMurdo)

Left: Union Theatre. (Alex McMurdo)

Jerwood Space. (Alex McMurdo)

The Jerwood Foundation has worked hard in the forty-five years since its creation to be acknowledged as a key player in the UK's creative arts scene. It is thus justly proud that the Jerwood Space is recognised as one of the best dance and theatre rehearsal spaces in Britain today.

44. City Hall and More London, SE1

More London is a mixed-use development built between 1998 and 2010 on a brown field site close to Potter's Fields. It covers an area of 13 acres between Tower Bridge and London Bridge and is made up of offices, shops, restaurants, a hotel, the Unicorn Children's Theatre, cafés, and bars. The massive development has played a major role in Southwark's economic and social regeneration and has become a destination in its own right, attracting approximately 10 million visitors per annum.

The architects commissioned for the More London development are the globally renowned Foster + Partners, well known for their designs of No. 30 St Mary Axe (the Gherkin), the Bloomberg Building and other signature buildings in the City of London. The architectural practice was not only responsible for the design of the complex but also for the creation of new streets, paths, piazzas, and public spaces. Since completion the highly glazed ten-storey

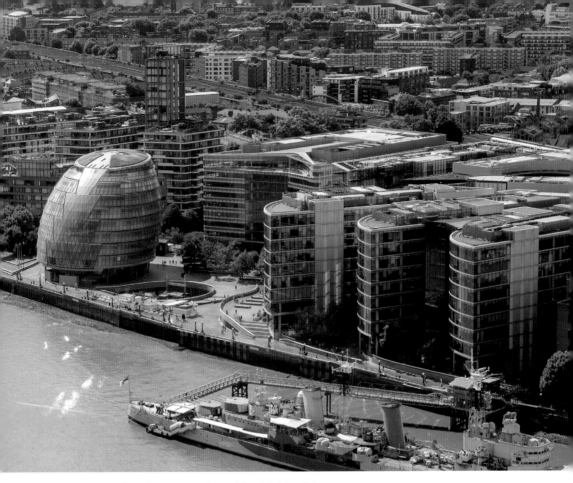

City Hall and More London. (Alex McMurdo)

office blocks have been mainly occupied as head offices by large companies such as Ernst and Young, PwC and Norton Rose Fulbright. All these buildings are highly attractive to their tenants not only for their location but also for the wealth of energy saving features they offer such as green roofs, cooling systems and solar hot water panels.

The Scoop, a sunken amphitheatre, is also part of the complex and sits beside the former City Hall building that was home to the Mayor of London and the Greater London Authority (GLA) from 2002 to 2021. A strange-shaped ten-storey building with seemingly no front or back, it has been likened to a motorbike helmet and a glass egg. City Hall's unusual bulbous shape was supposedly introduced to reduce its surface area to provide energy efficiency, but critics have disputed this as the building's excessive glass skin consumes so much energy.

Inside, the main feature of City Hall is its 500-metre (1,640-feet) helical walkway that ascends through the entire building providing views of its interior – which was intended by the architects to symbolise transparency and the accessibility of the democratic process. City Hall is currently empty and new tenants are being sought to fill this iconic building.

More London.
(Alex McMurdo)

45. Fashion and Textile Museum, No. 83 Bermondsey Street, SE1

Founded twenty years ago, the Fashion & Textile Museum is one of the most colourful and eye-catching buildings along Bermondsey Street. Based in a converted warehouse, the museum was the brainchild of the iconic fashion and textile designer Dame Zandra Rhodes and its resulting design the product of her collaboration with the Mexican architect Ricardo Legorreta (1931–2011). Legorreta certainly left his mark on the museum's exterior by painting it in stunning saffron and pink, which is in keeping with his buildings around the

Fashion and Textile Museum. (Alex McMurdo)

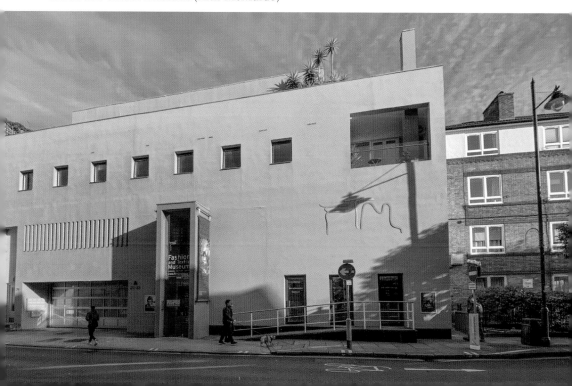

world so often decorated in flamboyant yellows, oranges, purples, and reds. The museum is even more special for being Legorreta's only work in Europe.

It is fitting that Zandra Rhodes chose Bermondsey to be the home for her museum as the area has long been associated with the leather, wool, hatting and textile trades. Unusually her museum collection is not on permanent public display but presented through temporary exhibitions, which have ranged from 'Swinging London – A Lifestyle Revolution to 'Riviera Style: Resort & Swimwear since 1900'. In addition to its exhibitions the museum is a centre of learning running educational workshops, lectures and teaching specialist skills to students for whom the collection is a valuable resource.

www.fashiontextilemuseum.org

46. Palestra House and One Blackfriars, Blackfriars Road, SE1

These two structures, sited about a five-minute walk from each other, demonstrate Southwark's enthusiasm for contemporary and distinctive buildings and have certainly changed the face of the borough. Palestra House, located directly opposite Southwark underground station, is the older of the two and was completed in 2006. It occupies a large corner plot beside Union Street looking out on to The Cut and creates a real presence in the area on account of its three upper cantilevered floors that hang 7.5 metres over Blackfriars Road. Palestra House's conspicuously odd shape together with its intense yellow glazed patterned façade is what particularly catches the eye of passers-by and makes the structure so unique. The use of vivid colour is also a feature within the building. Designed by Alsop Architects, the project cost £140 million and has since won several awards including the 2007 RIBA Commercial Building Prize. When Palestra House first opened it was home to the London Development Agency and the ground floor external pod served as its Information Centre. Since the Agency's closure in 2012, however, the entire building has been occupied by Transport for London.

One Blackfriars is equally as extraordinary and occupies a commanding position at the southern end of Blackfriars Bridge. Built as elite, luxury apartments the tower acts as a beacon for anyone making his or her way from the South Bank into the City of London. It has fifty storeys, stands 170 metres high and is easily identified by its beautifully curved and elegant silhouette. As every storey varies in shape and size each of the floorplates is different, which has meant that all the 9,000 pieces of glass used in the building have had to be individually fashioned.

Although planning permission was first given in 2009, the development took nine years to come into fruition, with the tower eventually completed in 2018. Designed by Simpson Haugh Architects, One Blackfriars has won many awards that have recognised not only its sustainability and infrastructure, but also its great style. Due to its highly individual appearance the tower has been nicknamed 'The Boomerang'.

Above left: Palestra House. (Alex McMurdo)

Above right: One Blackfriars. (Alex McMurdo)

Below: Pod beneath Palestra House. (Alex McMurdo)

47. Bankside 123 and Neo Bankside, Southwark Street, SE1

The site lying immediately behind Bankside was ripe for development when Tate Modern and the Millennium Bridge opened in the early 2000s. From its launch the art gallery was a big draw increasing footfall on the South Bank and contributed greatly to Southwark's regeneration. It was therefore no surprise that Land Securities, building on Tate Modern's success, decided to establish a commercial and residential quarter here. Within ten years three office blocks, Bankside 123, had been constructed on a large plot between the riverside and Southwark Street, which had previously housed unattractive 1950s government offices.

Allies and Morrison, a local firm of architects based in Southwark Street, were commissioned to design the buildings. As they were determined to ensure the project would benefit those working in the new offices, locals, and visitors to the area plans for the development included retail outlets, new public space, and street art. Building 1 to the west of Buildings 2 and 3 became known as the Blue Fin building because of the striking 2,000 blue vertical aluminium fins across its façade. Standing alone, it is the largest of the three while the other two blocks are set at an angle to one another and joined by a bridge. All three were built with flexibility in mind, to the highest standards of energy efficiency, with large floorplates and ground floor restaurants and shops. The designers also introduced

Bankside 123
Blue Fin Building.
(Alex McMurdo)

Above: Bankside 123 Buildings 2
and 3. (Alex McMurdo)

Right: Neo Bankside.
(Alex McMurdo)

a new route through the development to allow pedestrians ease of movement between Tate Modern and Southwark Street.

The NEO Bankside apartments lie beside the Blue Fin building, Tate Modern's 2016 extension and the Hopton Almshouses (see building 9). The residential development consists of four hexagonal buildings ranging from twelve to twenty-four storeys in height. Made from glass and steel, they are characterised by their red painted winter gardens, external bracing, and timber-clad panels. The apartments are particularly sought after – and boast magnificent views of the Thames skyline. Designed by Rogers Stirk Harbour + Partners, NEO Bankside was completed in 2012 and later shortlisted for RIBA's 2015 Stirling Prize. The development has won numerous awards for its architectural merit and its urban landscaping.

48. The Shard, London Bridge Street, SE1

A decade after its introduction to London's skyline the Shard remains the most prominent feature of the South Bank and raises its head high above the surrounding buildings. Unlike the cluster of high-rise buildings downstream at Canary Wharf or across the river in the City of London, the Shard stands alone, a narrow pyramidal structure that appears to disappear into the clouds. At almost 310 metres (1,016 feet) high the glazed structure is London's tallest building. The idea for it came from property developer Irvine Sellar (1934–2017), who purchased the 1-acre site from PwC and had the ambition to turn it into a vertical city. His vision was to build a structure close to a major transport hub that could be put to many uses and would incorporate not just offices, but a range of businesses, as well as accommodation, and perhaps even a tourist attraction. He foresaw a place that people could work, live, and relax in and benefit from fabulous views of London. To bring his dream about Sellar commissioned the award-winning Renzo Piano (1937) to take on the project. Piano took great inspiration from London's historic sixteenth-century church spires, as well as the masts of boats on the river, in his subsequent design for the Shard. Although not a great fan of towers, Piano forged a new style for the Shard whereby the building's broadest floorplates would be placed at its base and be suitable for office space. The footplates above would gradually decrease in size and accommodate areas for restaurants and bars, a hotel, apartments with views on every side and, at the summit, a public viewing space.

The construction was not all easy going; the planning process was lengthy, a public enquiry was held, and the financial crisis of 2008 took its toll. However, Sellar got backing from the State of Qatar as a partner and finally the project took off.

The Shard today is a definite landmark and an established part of the London Bridge area. It is a great destination and visitors flock to experience the views from its peak viewing gallery, The View from the Shard.

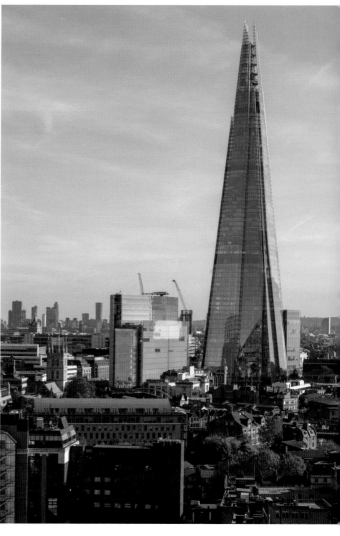

Above: The Shard. (Alex McMurdo)

Right: The Shard. (Alex McMurdo)

49. One Tower Bridge and the Bridge Theatre, Potters Fields Park, SE1

One Tower Bridge is primarily a prestigious residential development enviably sited besides London's historic Tower Bridge. It is surrounded by beautifully landscaped public gardens and made up of several buildings including a wide low-rise building where the Ivy Brasserie and Bridge Theatre are located, a twenty-storey tower and three apartment blocks.

The Bridge Theatre was set up in 2017 by the former executive and artistic directors of the National Theatre, Nicholas Hytner and Nick Starr, to be home to the London Theatre Company (LTC). Their aim was to create a new independent theatre on the south side of the Thames away from the West End's mainstream theatre hub and to concentrate on the staging of plays rather than grand musicals. Hytner and Starr's eagerness to promote new writing has been a fundamental

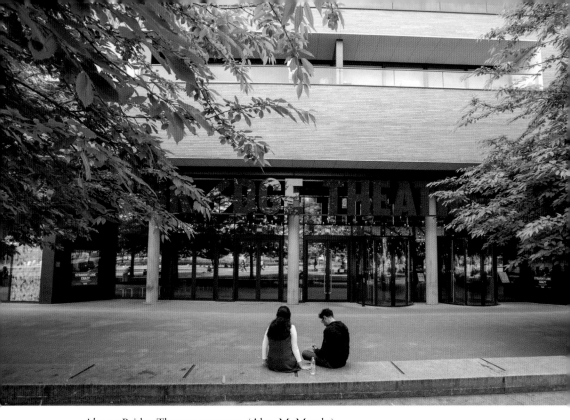

Above: Bridge Theatre entrance. (Alex McMurdo)

Below: Bridge Theatre auditorium. (Alex McMurdo)

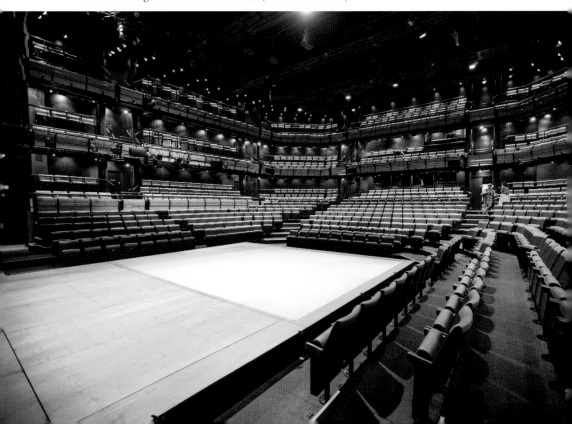

Bridge Theatre foyer and bar. (Alex McMurdo)

tenet of the LTC and they have supported the works of several new playwrights, especially women, since the theatre opened its doors. The Bridge Theatre seats 900 people in its state-of-the-art auditorium and is an extremely flexible space that allows productions requiring different stage arrangements to be easily presented. The theatre is particularly popular for its spacious and light-filled foyer that enjoys spectacular views of Tower Bridge and the river.

www.bridgetheatre.co.uk

50. Borough Yards, Stoney Street, SE1

Southwark's dramatic railway viaducts and brick arches are a significant part of South London's industrial heritage and yet until recent times many of them were practically derelict, in a state of neglect or even hidden from view. The Borough Yards developers MARK working with SPPARC architects have recently transformed the area between Borough Market and the Thames with their wonderful restoration of the double-height railway arches and their careful interlinking of old structures with new ones. The massive Victorian brick arches have been renovated and given simple glass fronts and are now occupied by a great range of shops, cultural venues, cafés, and restaurants. New paths, public spaces, and courtyards have been established throughout the quarter, as well as an

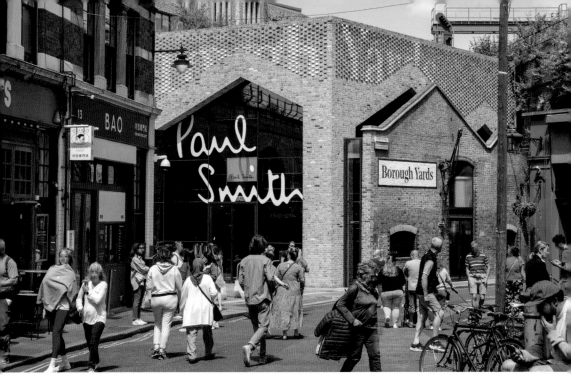

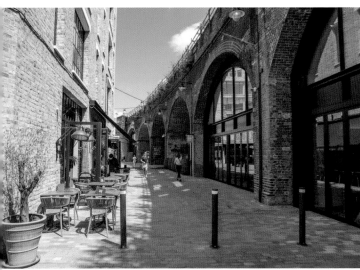

Above: Borough Yards.
(Alex McMurdo)

Left: Borough Yards.
(Alex McMurdo)

arcade and an Everyman cinema. Also, old warehouses have been refurbished and a vanished medieval street system has been revived.

Despite being a stone's throw away from excellent transport links, as well as the attractions of Borough Market, Southwark Cathedral and the Shard, the area lacked a good retail shopping hub until recent improvements to London Bridge station. Now Borough Yards offers an even greater range of shopping and dining opportunities including a Paul Smith flagship store and restaurants such as Vinoteca, Barrafina and Parrillan.

Glossary

Art Deco	An architectural and decorative style of the 1920s and 1930s that used vibrant colours and patterns.
Art Nouveau	A popular style between 1890 and 1910, which is often characterised by its curves and swirling decoration.
Baroque	A flamboyant and monumental architectural style in fashion around 1600 to 1750.
Brutalism	An architectural style of the mid to late 1900s. It features rough or raw concrete, often in large forms.
Edwardian	Covers the styles mainly in use during the reign of King Edward VII (r. 1901–10), such as Gothic Revival, neo-Georgian and baroque revival.
Georgian	The style of architecture between 1714 and 1830, during the reigns of George I, II, III and IV, when classical proportions were introduced into all types of buildings.
Gothic	Refers to the style of the Middle Ages, which is renowned for its pointed arches, rib vaulting and large windows. Covers the period from around 1180 to 1520 and is divided into Early English Gothic, Decorated and Perpendicular styles.
High-Tech	This style emerged in the 1970s, when designers selected lightweight building materials. It is characterised by the external exposure of mechanical services.
Italianate	This style of architecture was most prevalent in the early to mid 1800s. It is used in secular buildings and based on palatial homes in Renaissance Italy.
Modernism	This art and architectural style of the twentieth century discarded adornment and used modern materials in a minimalist fashion. It is typified by the use of reinforced concrete, iron, steel, metal and glass.
Palladian	Properly formulated, elegant and classical architecture introduced into England from the early 1600s.
Postmodernism	A movement of the late 1900s that departed from functional, conventional architecture. It merged art and functionality –

creating an 'anything goes' culture – and incorporated the unusual use of colour and materials, historical elements and decoration.

Victorian During the long reign of Queen Victoria (r. 1837–1901), many historic styles were prevalent such as Gothic Revival, Renaissance and Queen Anne Revival. Other popular styles included Italianate, neoclassical and Arts and Crafts.

About the Author

Lucy McMurdo is a modern history graduate and native Londoner who has lived in the capital all her life. In 2003 when she qualified as a London Blue Badge Tourist Guide she combined two of her major loves – history and London – and has been sharing her knowledge of the city with local and foreign visitors ever since. Always keen to explore and learn about London's secrets, she spends many hours 'walking the streets' looking out for hidden corners, unusual curiosities, as well as architecturally significant buildings and ones that have a story to tell.

Lucy's tour guiding career began over thirty years ago when she first guided overseas visitors around the UK. Since then, in addition to tour guiding she has been greatly involved in training and examining the next generation of tour guides. She has created, taught and run courses in London's University of Westminster and City University, and also developed guide-training programmes for the warders and site guides at Hampton Court Palace.

Most recently Lucy has been writing about the city she is so passionate about and is the author of eight London guidebooks: *The City of London in 50 Buildings*, *Highgate and Hampstead in 50 Buildings*, *Islington and Clerkenwell in 50 Buildings*, *Chiswick in 50 Buildings*, *Bloomsbury in 50 Buildings*, *Explore London's Square Mile*, *Streets of London* and *London in 7 Days*.

Acknowledgements

The author would like to thank all the people and organisations that have facilitated the production of this book. In particular to acknowledge the help and assistance given by staff at the LaLiT Hotel, the Apothecaries' Hall, The Young Vic Theatre, St George the Martyr Church, the Old Operating Theatre and Herb Garret Museum, Anchor Bankside, the Dixon Hotel, the Hop Exchange and the Bridge Theatre.

Once again, I have to give great thanks to my husband, Alex McMurdo, for producing such wonderful images and for his strong support and encouragement during the writing of this book. I also want to thank him and Jo McMurdo for proofreading the text and for providing most valuable feedback and constructive criticism.

I would like to take this opportunity too to thank Amberley Publishing for commissioning the book, and to acknowledge the excellent support and hard work of Jenny Bennett, Nick Grant and all the team.